Art is...

Art is...

THE METROPOLITAN
MUSEUM OF ART

Abrams
New York

"WHAT IS ART?" is a question with no single answer — in fact, this book has nearly two hundred responses.

The answers presented in the following pages are simple observations and reactions to art. All are subjective reflections about what is seen and are open to discussion. Some of the responses given speak to technique, while others are descriptive or invoke emotion. A Michelangelo sketch is practice; a Vermeer painting is mastery. A Nigerian mask is symmetry; a Van Gogh still life is composition. A Babylonian lion is fierce; a Duccio portrait is tender.

Reaching across time and form, from ancient statues to medieval tapestries to Baroque instruments to Impressionist paintings to contemporary costumes, the selected works of art represent The Metropolitan Museum of Art's vast collection of over two million objects and seventeen curatorial departments. Detailed commentary about the works can be found on the Museum's website at www.metmuseum.org.

Because there are no absolute answers—a single work could easily have ten different answers, though for brevity only one was selected—readers are encouraged to observe, to think, to debate, and to develop their own definitions of "art."

Art is practice,

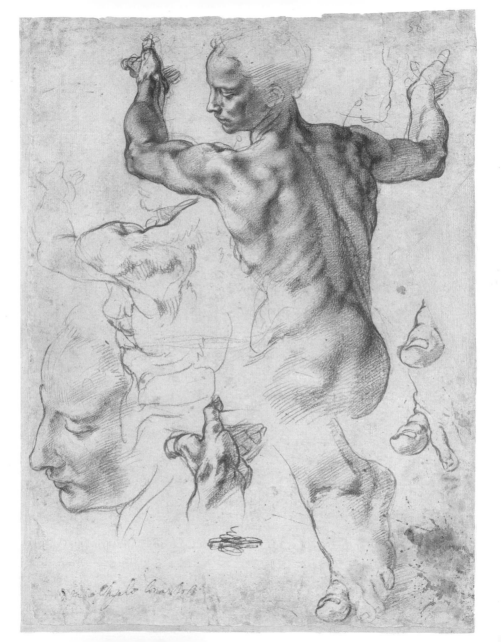

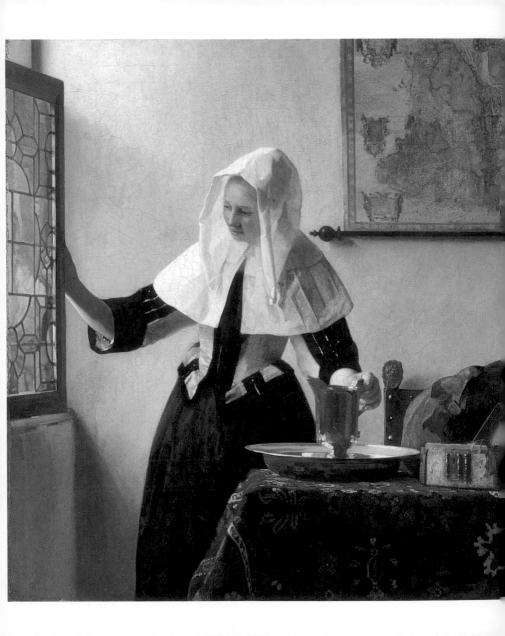

art is mastery.

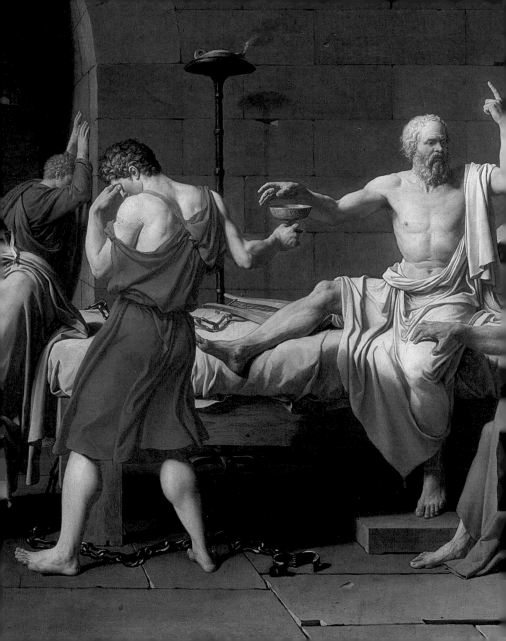

Art is a story,

The Death of Socrates (detail)

Jacques-Louis David, French, 1748 1825

Oil on canvas, 51 × 77^1/$_4$ in., 1787

Catharine Lorillard Wolfe Collection, Wolfe Fund, 1931 31.45

art is an impression.

Bridge over a Pond of Water Lilies
Claude Monet, French, 1840–1926
Oil on canvas, 36^1/$_2$ × 29 in., 1899
H. O. Havemeyer Collection, Bequest of Mrs. H. O. Havemeyer, 1929. 29.100.113

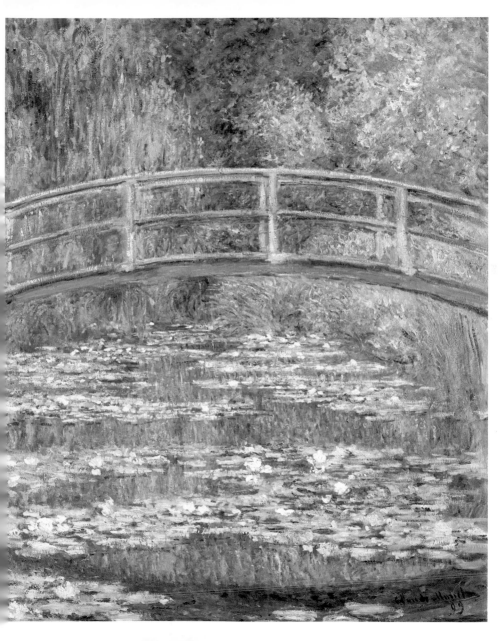

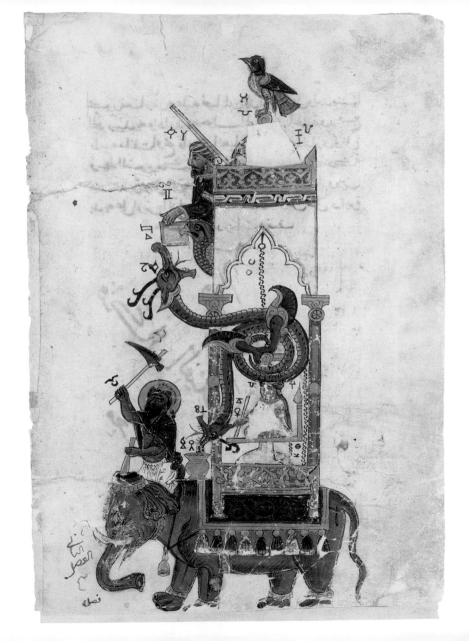

Art is inventive,

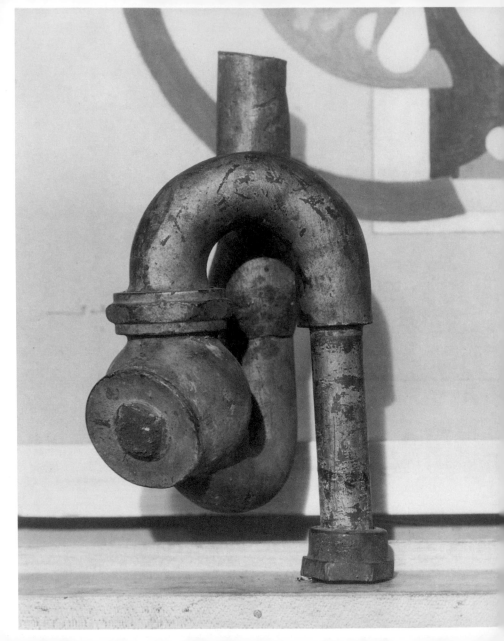

art is found.

Art is simple,

Head from the figure of a woman
Cycladic, Early Cycladic II
Marble, H. 9$^{15}/_{16}$ in., ca. 2700–2500 BC
Gift of Christos G. Bastis 1964 64.246

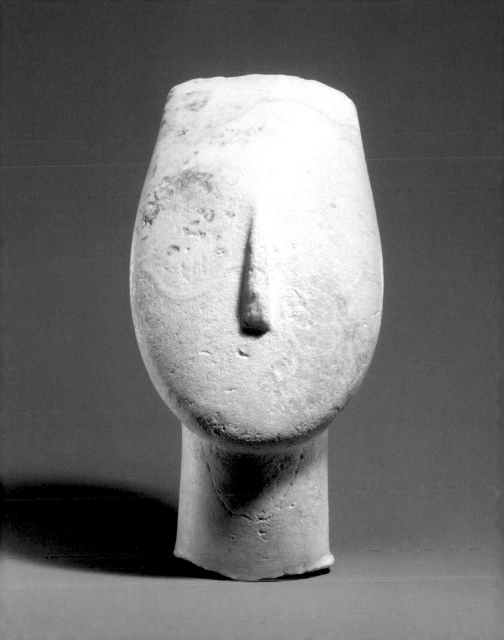

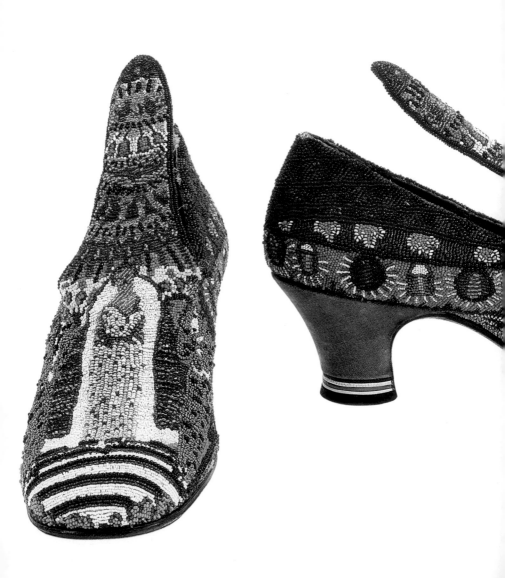

art is detailed.

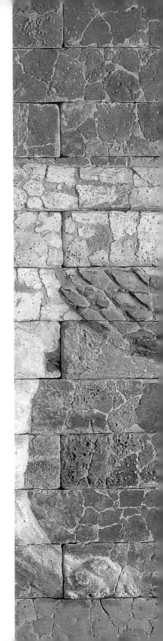

Art is fierce,

Panel with striding lion (detail)
Mesopotamia (Babylon), Neo-Babylonian period
Glazed brick, H. 38¹/₄ in., ca. 604–562 BC
Fletcher Fund, 1931 31.13.2

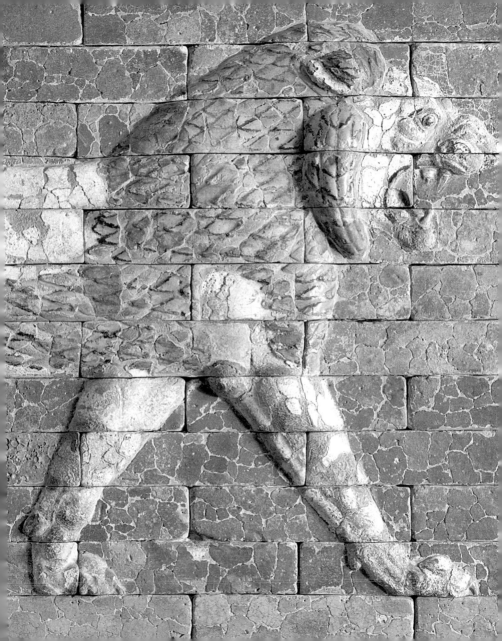

art is tender.

Madonna and Child

Duccio di Buoninsegna, Italian (Siena), active by 1278, died 1318

Tempera and gold on wood, 11 × 8 1/4 in., ca. 1300

Purchase, Rogers Fund, Walter and Leonore Annenberg and The Annenberg Foundation
Gift, Lila Acheson Wallace Gift, Annette de la Renta Gift, Harris Brisbane Dick, Fletcher,
Louis V. Bell, and Dodge Funds, Joseph Pulitzer Bequest, several members of The
Chairman's Council Gifts, Elaine L. Rosenberg and Stephenson Family Foundation Gifts,
2003 Benefit Fund, and other gifts and funds from various donors, 2004 2004.442

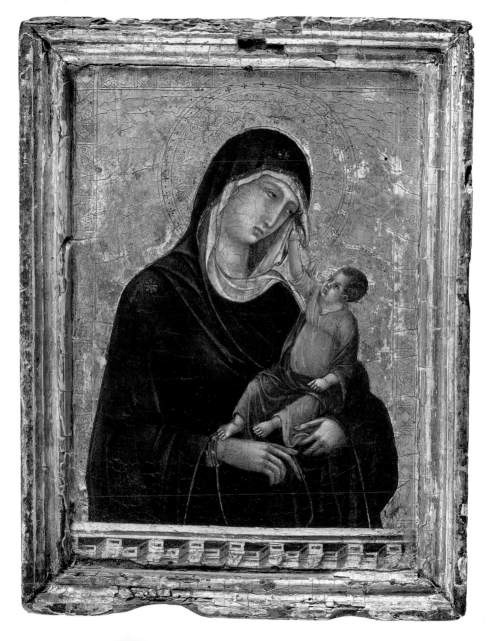

Art is symmetry,

Masquerade element: ram head (Omama)
Nigeria; Yoruba Peoples, Owo Group, 17th–19th century
Ivory, wood or coconut shell inlay, H. 6 in.
Gift of Mr. and Mrs. Klaus G. Perls, 1991 1991.17.123

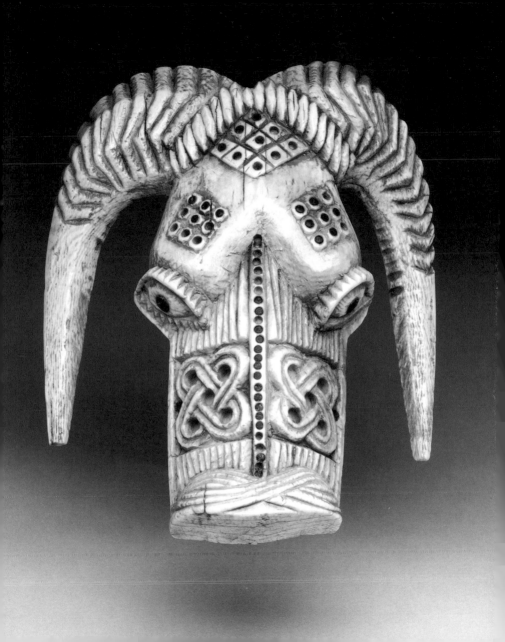

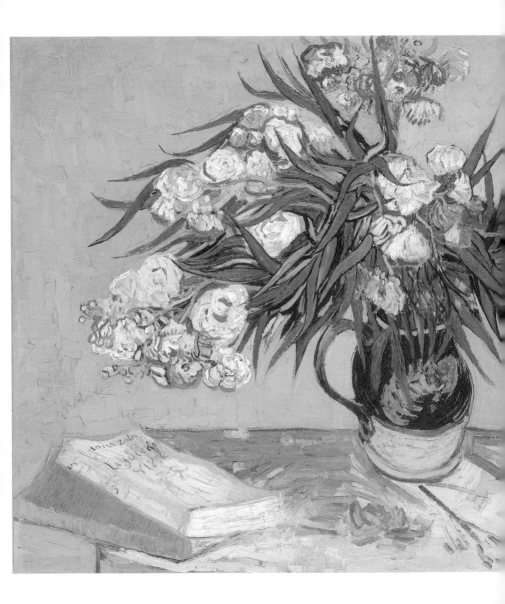

art is composition.

Oleanders

Vincent van Gogh, Dutch, 1853–1890

Oil on canvas, 23³/₄ × 29 in., 1888

Gift of Mr. and Mrs. John L. Loeb, 1962 62.24

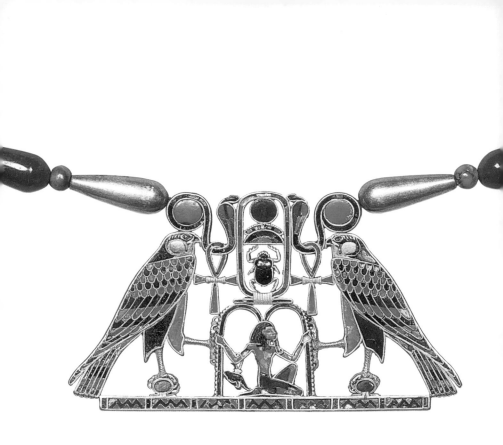

Art is symbolic,

art is descriptive.

The Harvesters (detail)
Pieter Bruegel the Elder, Netherlandish, ca. 1525–1569
Oil on wood, 46⁷/8 × 63³/4 in., 1565
Rogers Fund, 1919 19.164

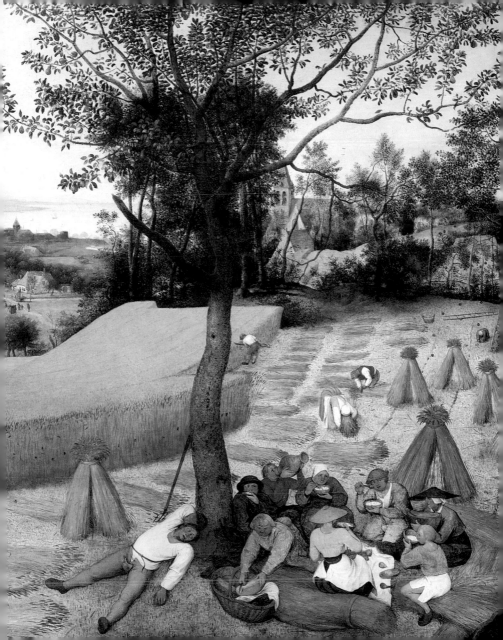

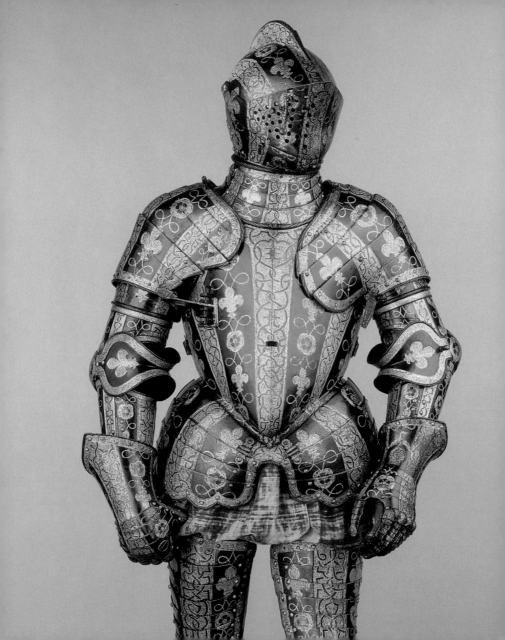

Art is guarded,

art is uninhibited.

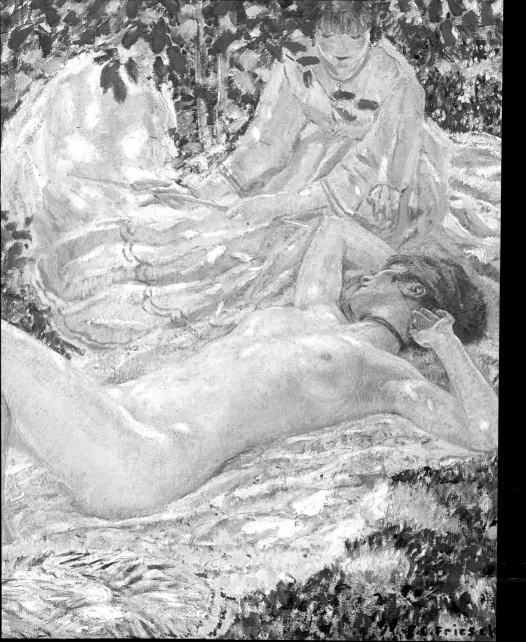

Art is worn,

Dress

Yves Saint Laurent, French, 1936–2008

House of Yves Saint Laurent, Paris (founded 1962)

Wool, fall/winter 1965–66

Gift of Mrs. William Rand, 1969 C.I.69.23

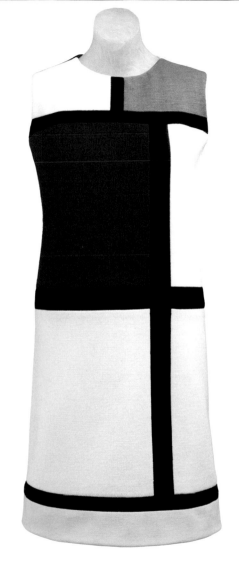

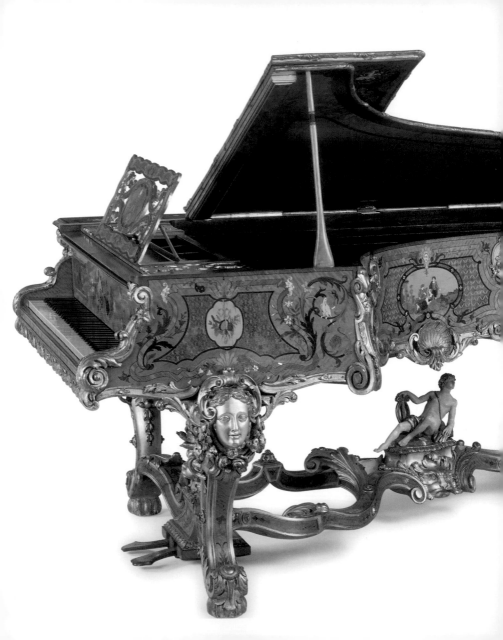

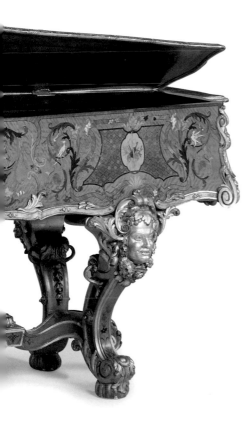

art is heard.

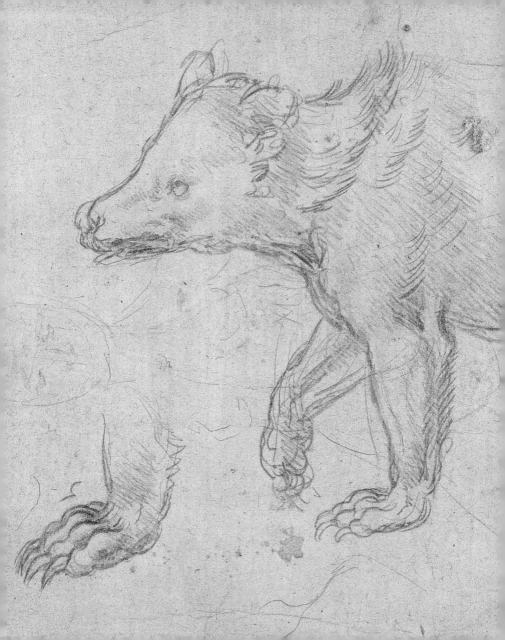

Art is study,

A Bear Walking (detail)
Leonardo da Vinci, Italian (Florence), 1452–1519
Metalpoint on light buff prepared paper,
4$^1/16$ × 5$^1/4$ in., ca. 1490
Robert Lehman Collection, 1975 1975.1.369

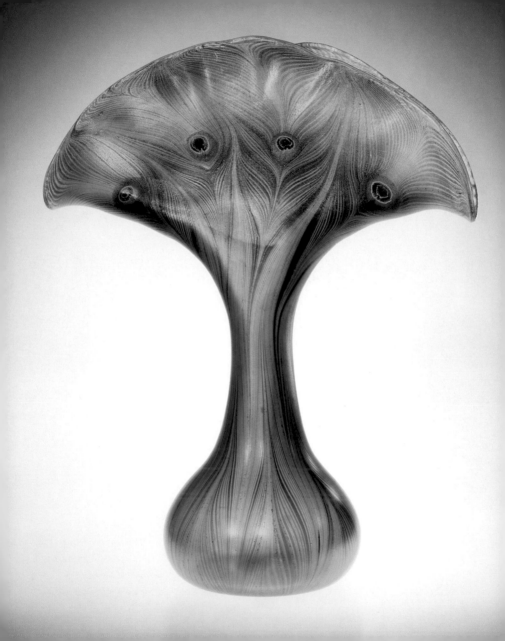

art is craft.

Vase

Louis Comfort Tiffany, American, 1848–1933

Tiffany Glass and Decorating Company (1892 1902)

Favrile glass, H. 14 1/8 in., 1893–96

Gift of H. O. Havemeyer, 1896 96.17.10

Art is a record,

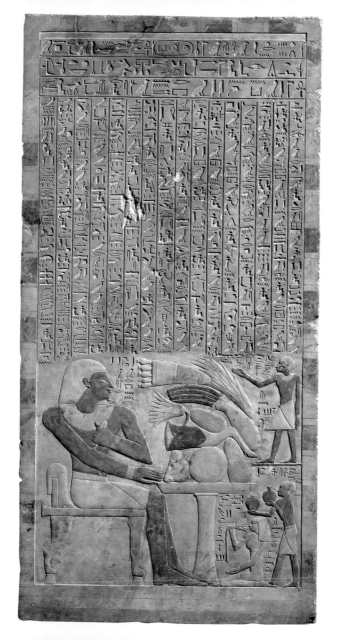

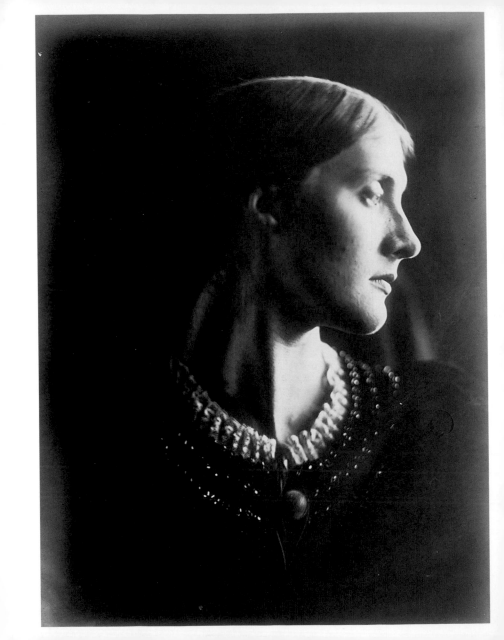

art is a moment.

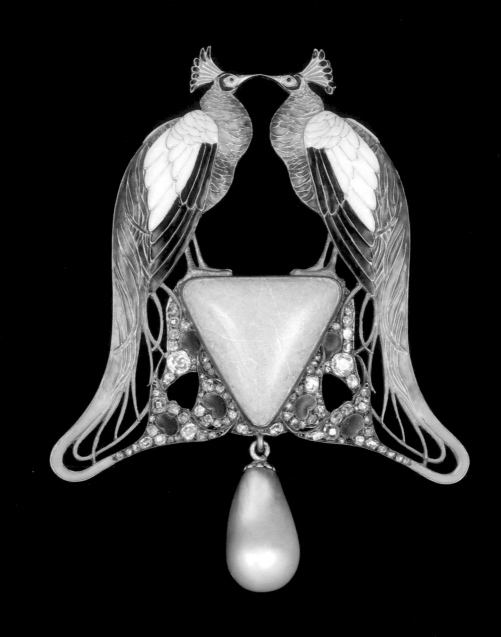

Art is fanciful,

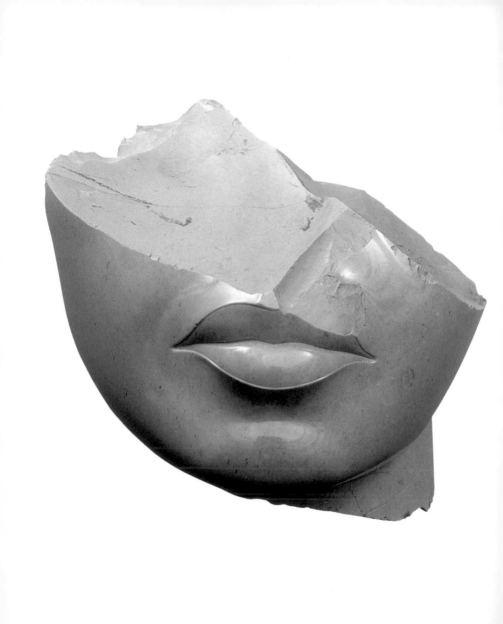

art is understated.

Art is pattern,

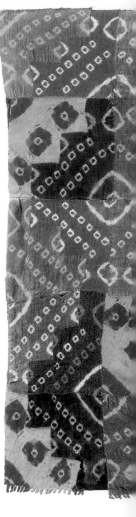

Tunic
Peru (Wari), pre-Columbian period
Camelid hair, 34 x 46 in., 700–850
Gift of Rosetta and Louis Slavitz, 1986 1986.488.3

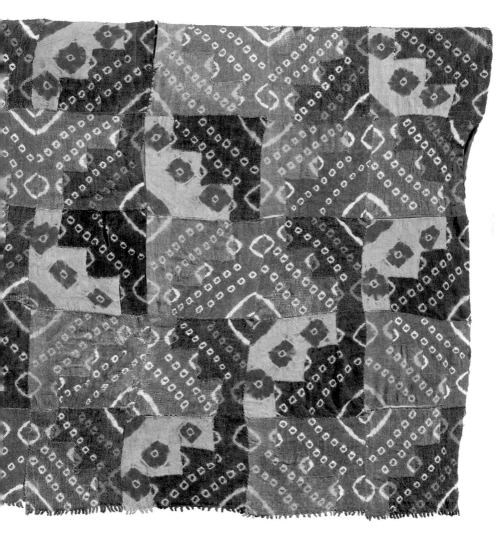

art is brushstroke.

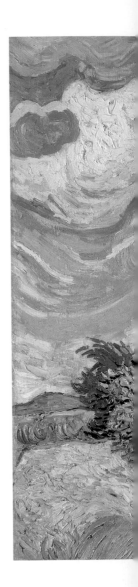

Wheat Field with Cypresses
Vincent van Gogh, Dutch, 1853–1890
Oil on canvas, 28³/₄ × 36³/₄ in., 1889
Purchase, The Annenberg Foundation Gift, 1993 1993.132

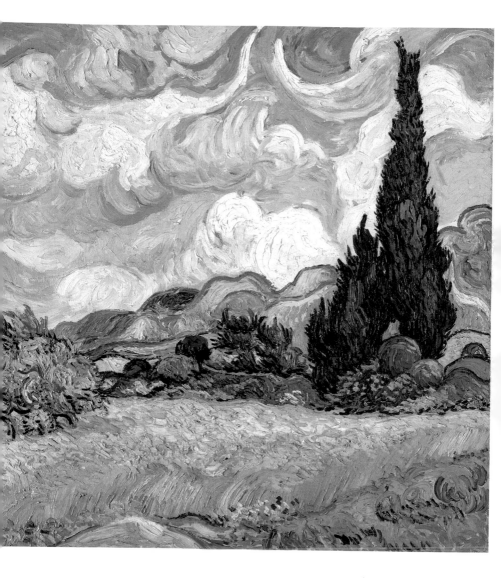

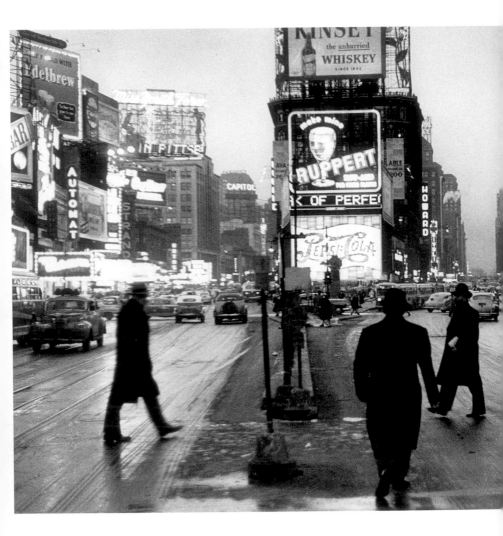

Art is random,

art is ritual.

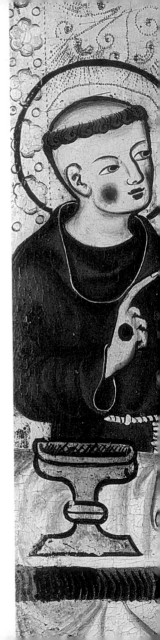

The Bishop of Assisi Giving a Palm to Saint Clare (detail)
Germany (Nuremberg), ca. 1360
Tempera and gold on oak panel, 13¹/₄ × 8³/₄ in.
The Cloisters Collection, 1984 1984.343

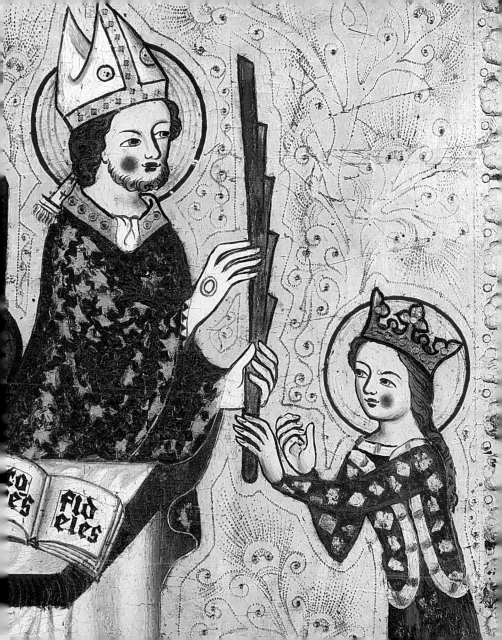

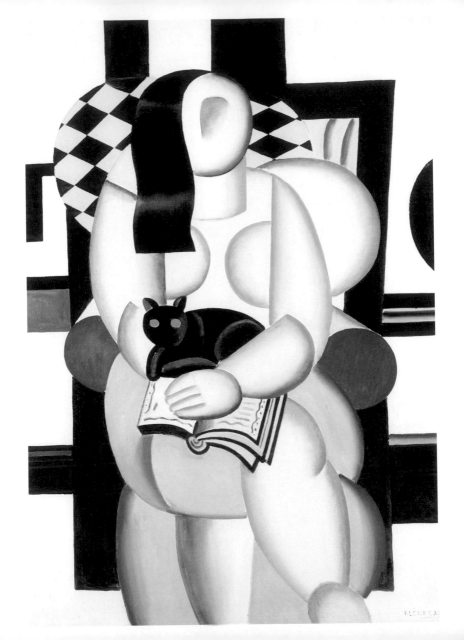

Art is shape,

art is color.

Sandal
Salvatore Ferragamo, Italian, 1898–1960
House of Salvatore Ferragamo (founded 1929)
Leather, cork, H. 5 ¹/₂ in., 1938
Gift of Salvatore Ferragamo, 1973 1973.282.2

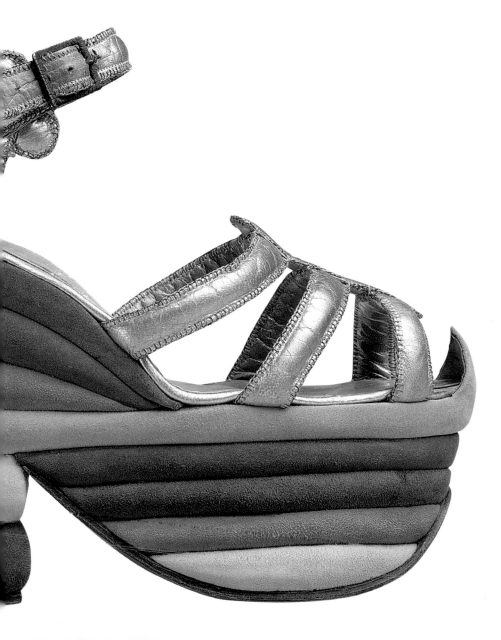

Art is sight,

Scherzo di Follia (Game of Madness)

Pierre-Louis Pierson, French, 1822–1913

Gelatin silver print from glass negative, $15^{11}/_{16} \times 11^3/_4$ in., 1861–67, printed ca. 1930

Gilman Collection, Gift of The Howard Gilman Foundation, 2005 2005.100.198

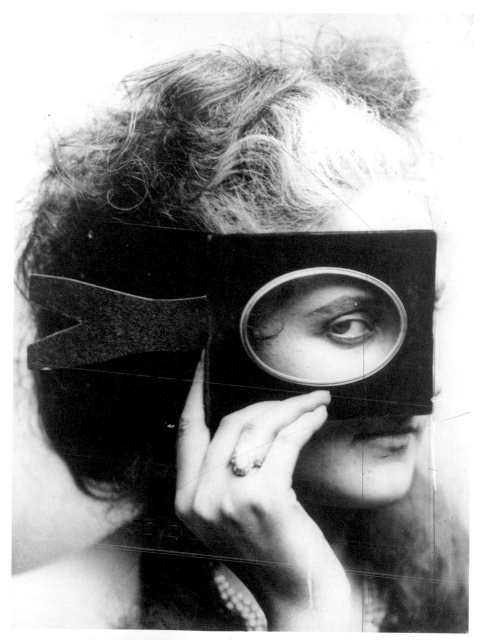

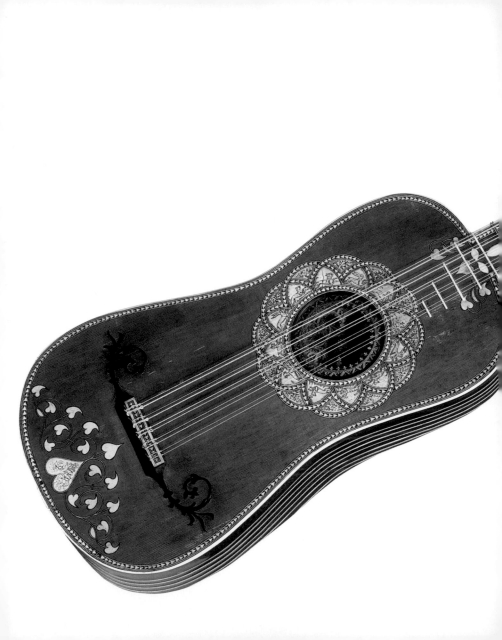

art is sound.

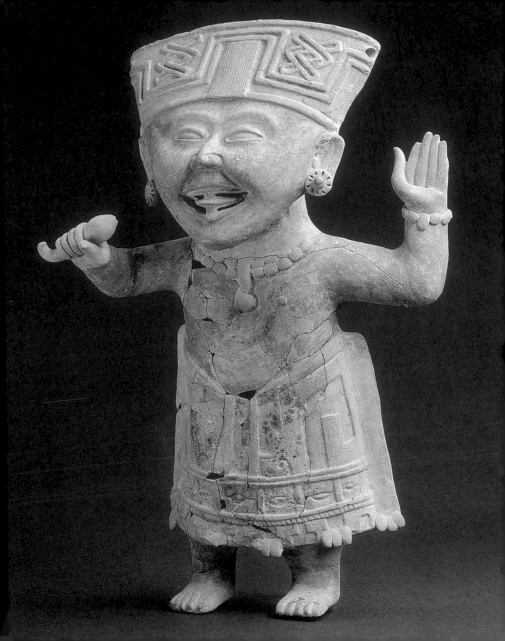

Art is delight,

art is sorrow.

Memorial painting (detail)
Sally Miller, American, 1811
Watercolor and ink on silk, 28 × 32³/8 in.
Rogers Fund, 1948 48.81

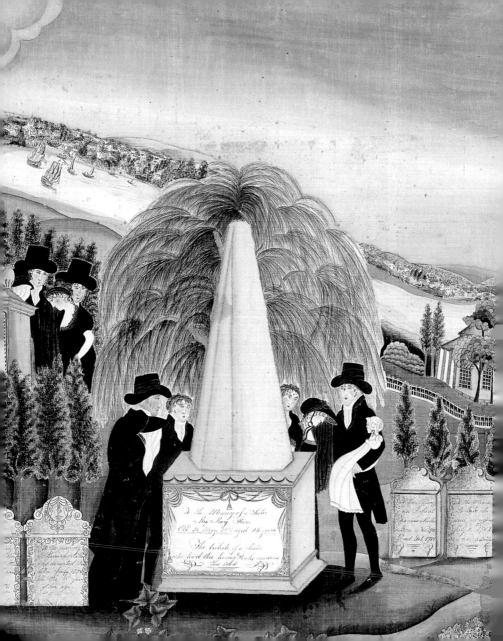

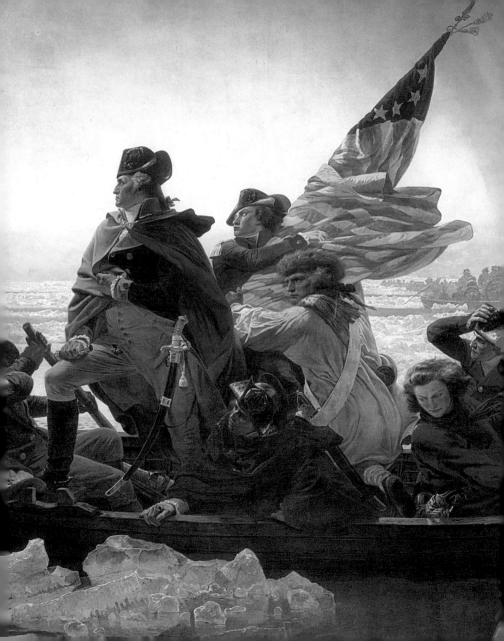

Art is history,

art is allegory.

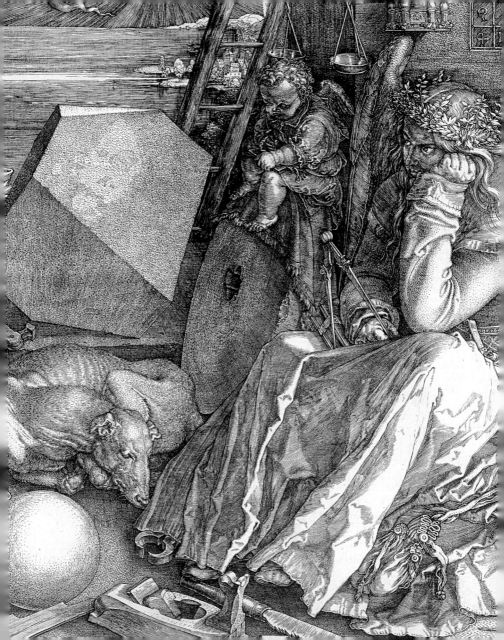

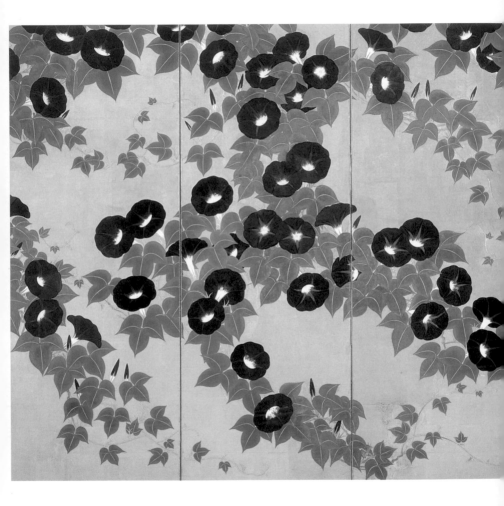

Art is gilded,

Morning Glories (detail)
Suzuki Kiitsu, Japanese, 1796–1858
Six-panel screen; ink, color, and gold on gilt paper,
5 ft. 10³/₁₆ in. × 12 ft. 5¹/₂ in., early 19th century
Seymour Fund, 1954 54.69.1

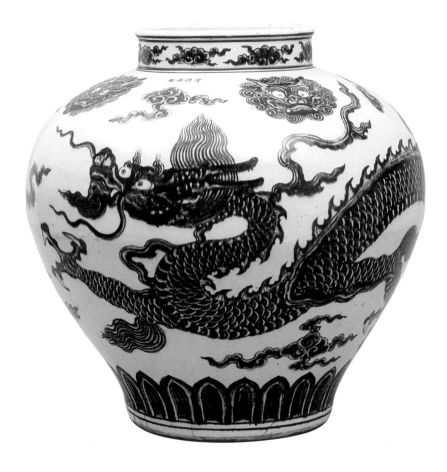

art is glazed.

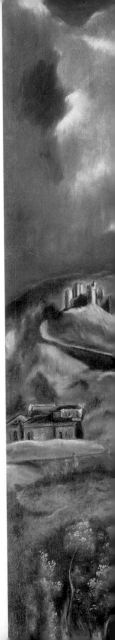

Art is dramatic,

View of Toledo (detail)

El Greco (Domenikos Theotokopoulos), Greek, 1540/41–1614

Oil on canvas, 47³/₄ × 42³/₄ in.

H. O. Havemeyer Collection, Bequest of Mrs. H. O. Havemeyer, 1929 29.100.6

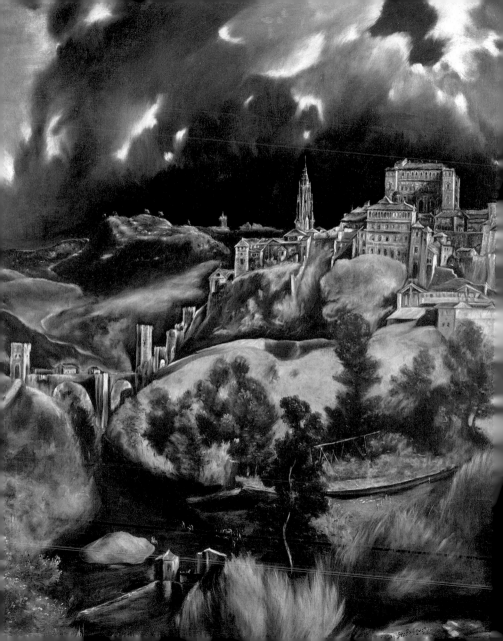

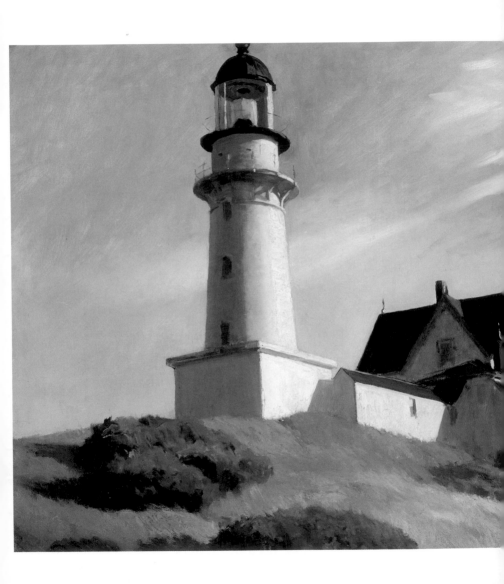

art is serene.

Art is industrial,

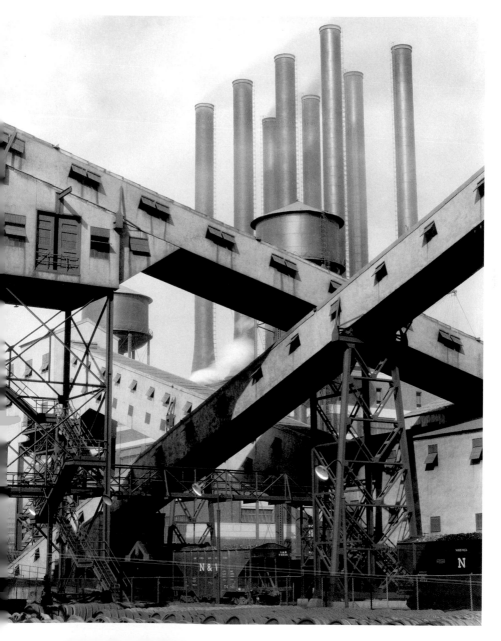

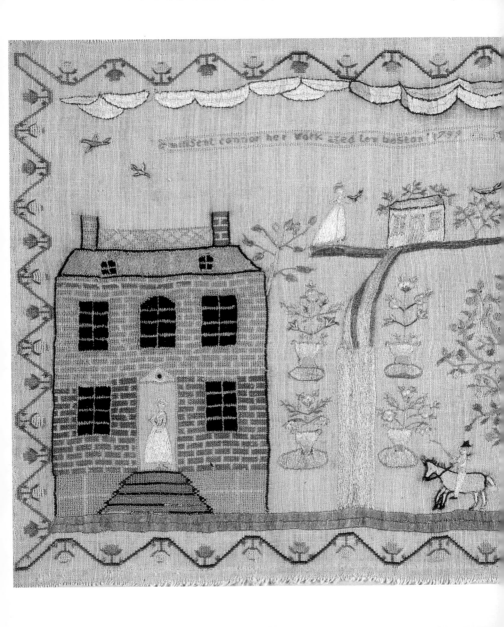

art is homespun.

Sampler

Millsent Connor, American, b. 1789

Embroidered silk on linen, 21 1/8 x 16 1/4 in., 1799

Gift of Edgar William and Bernice Chrysler Garbisch, 1974 1974.42

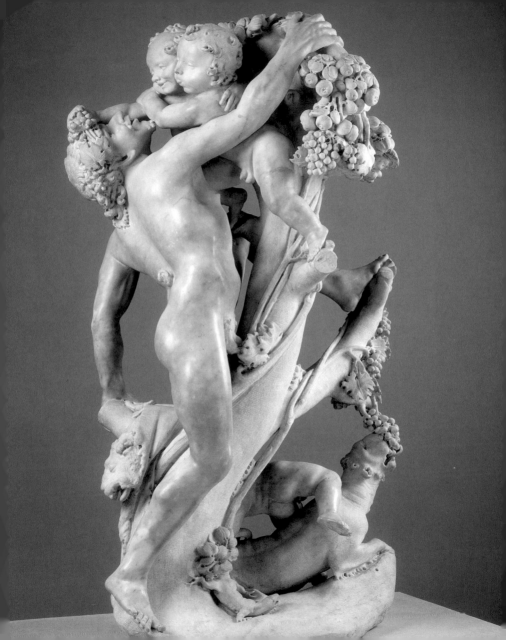

Art is chiseled,

art is hammered.

Plaque: winged creatures approaching stylized trees (detail)
Iran (said to be from Ziwiye), ca. 8th–7th century BC
Gold, H. 8 5/16 in.
Purchase, Ann and George Blumenthal Fund, 1954 54.3.5
Rogers Fund, 1962 62.78.1a, b

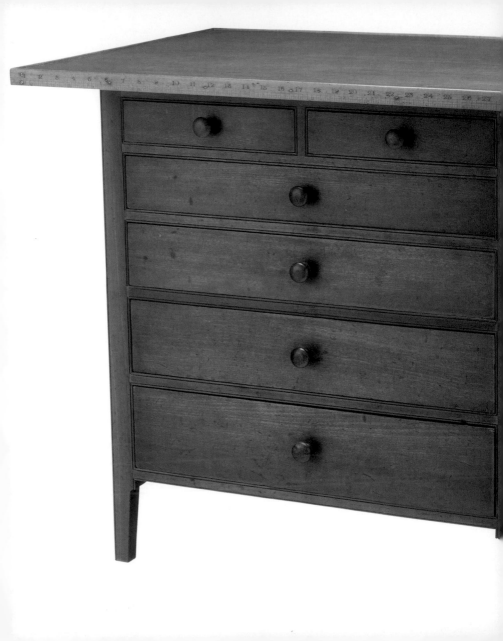

Art is function,

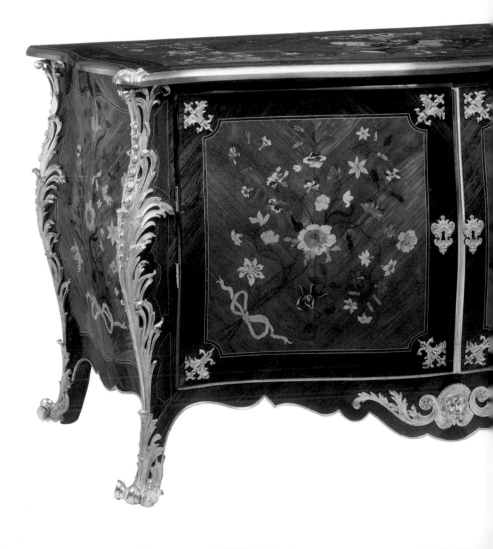

art is form.

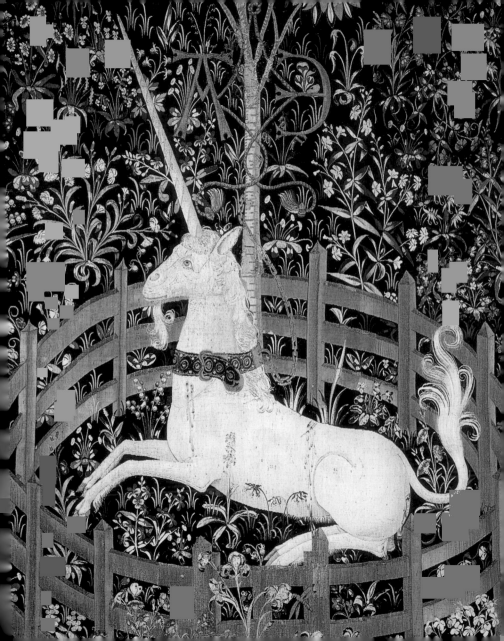

Art is woven,

art is carved.

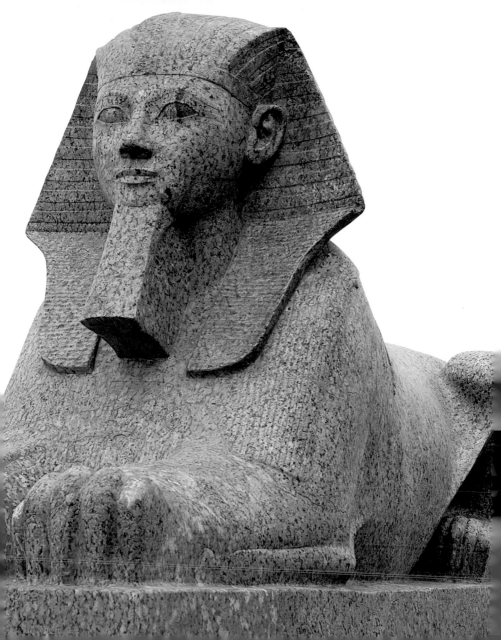

Art is longing,

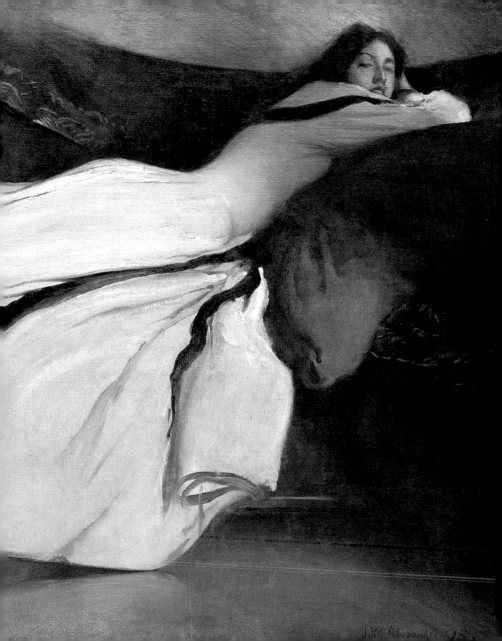

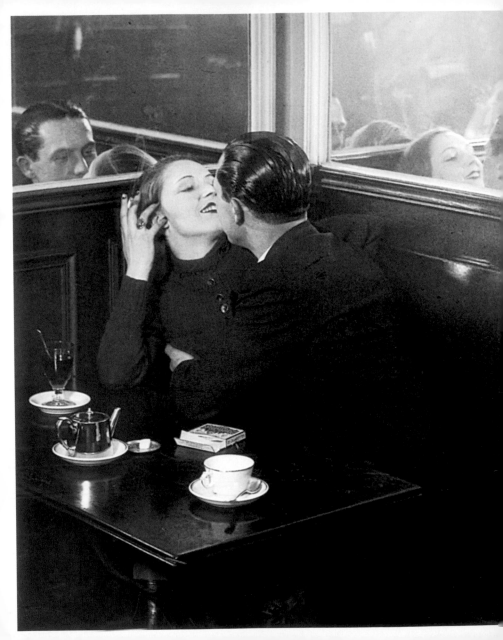

art is desire.

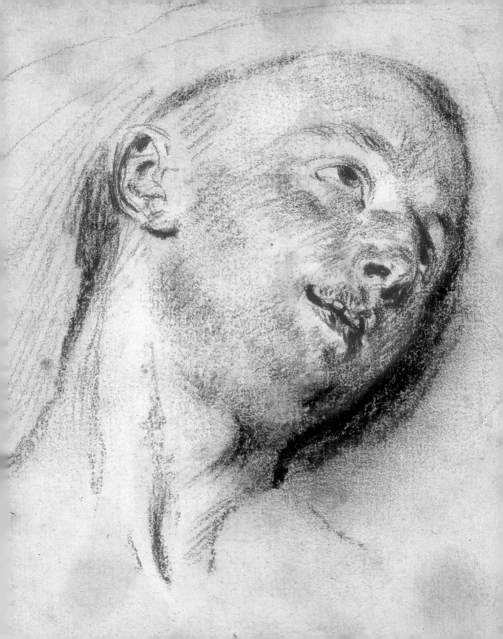

Art is sketch,

art is illumination.

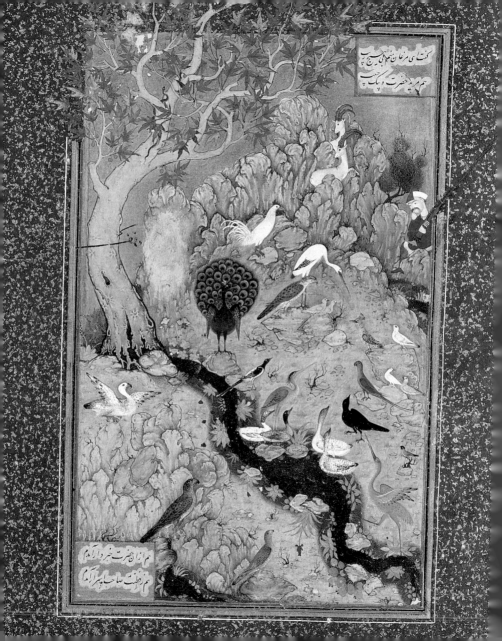

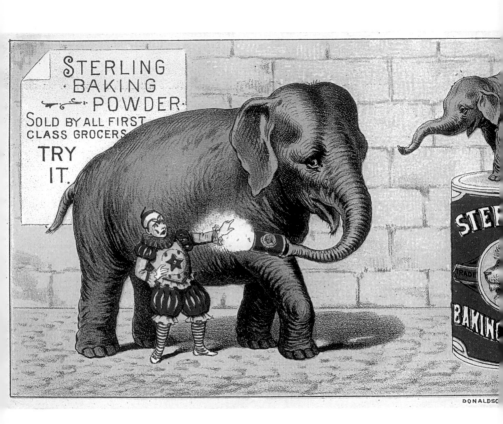

IVE POINTS, N.Y.

Art is advertisement,

Sterling Baking Powder
American, ca. 1880
Printed by Donaldson Brothers (New York)
Chromolithograph, $3\,^5/_{16}$ x $5\,^5/_8$ in.
The Jefferson R. Burdick Collection, Gift of Jefferson R. Burdick Burdick 17, p.49

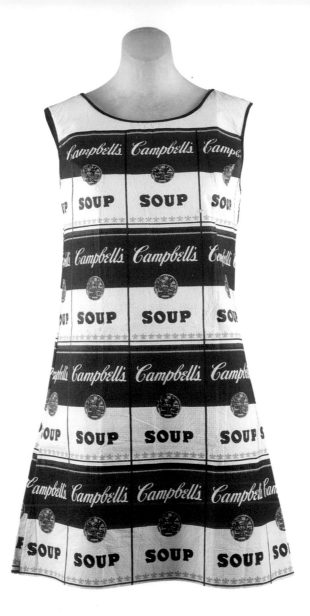

art is adaptation.

"The Souper" Dress
American, 1966–67
Paper, L. 32 in.
Purchase, Isabel Schults Fund and Martin and Caryl
Horwitz and Hearst Corporation Gifts, 1995 1995.178.3

Art is above your head,

Bedroom from the Sagredo Palace, Venice

Italian (Venice), ca. 1718

Stuccowork probably by Abbondio Stazio, Italian (Massagno), 1675–1745;

and Carpoforo Mazzetti, Italian, ca. 1684–1748; probably after a model

by Gaspare Diziani, Italian (Belluno), 1689–1767

Wood, stucco, marble, glass, H. 25 ft. 2 in.

Rogers Fund, 1906 06.1335.1a–d

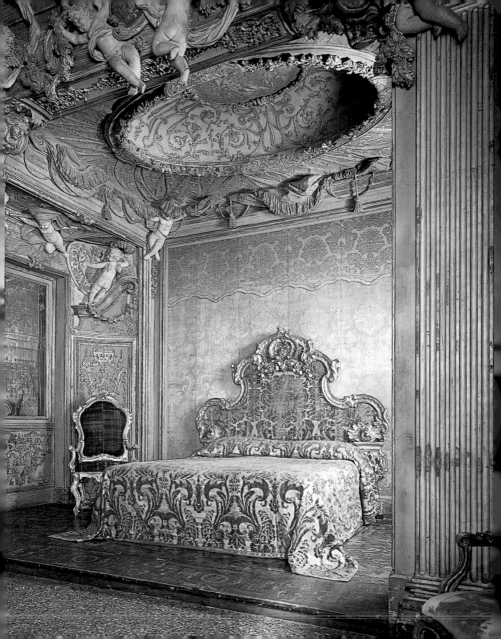

art is under your feet.

Animal carpet (detail)
Iran (probably Kashan), second half 16th century
Silk (warp, weft, and pile); asymmetrically knotted pile, $94^{7}/8 \times 70^{1}/_{16}$ in.
Bequest of Benjamin Altman, 1913 14.40.721

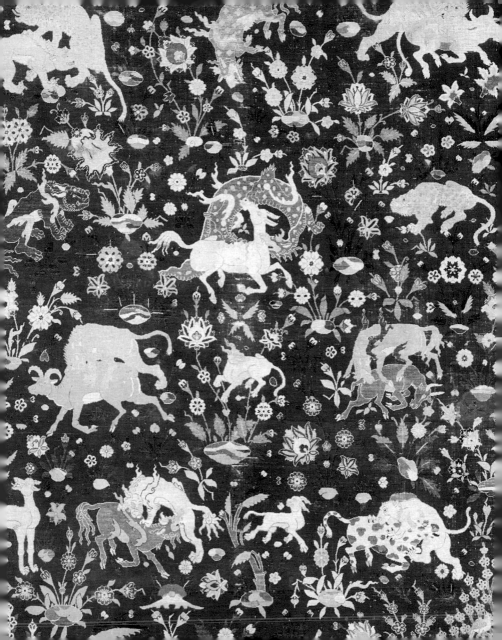

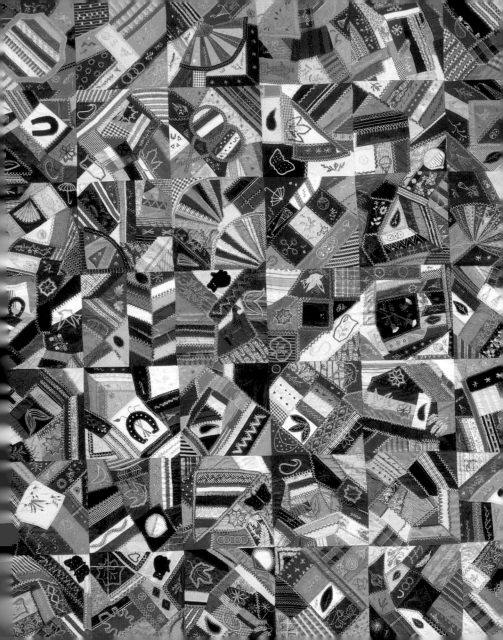

Art is memory,

art is fantasy.

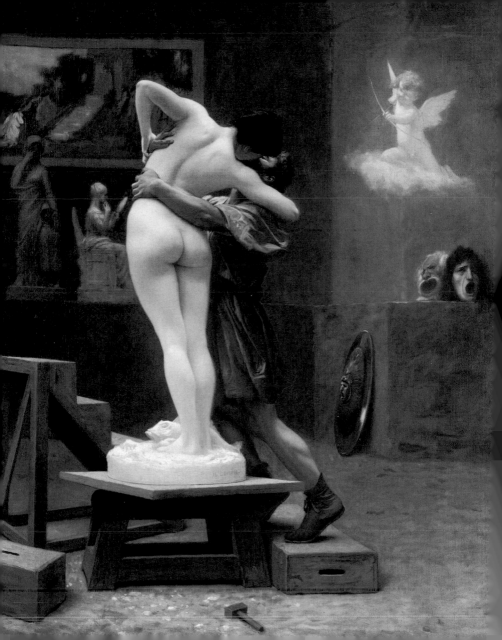

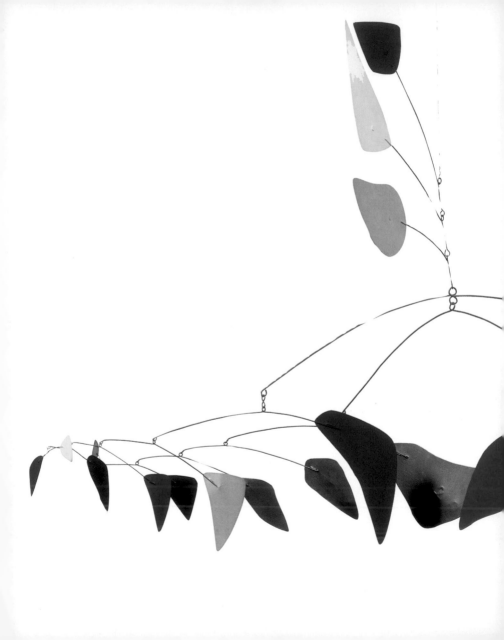

Art is moving,

art is still.

Still Life with Apples and a Pot of Primroses (detail)
Paul Cézanne, French, 1839–1906
Oil on canvas, 28³/₄ × 36³/₈ in., ca. 1890
Bequest of Sam A. Lewisohn, 1951 51.112.1

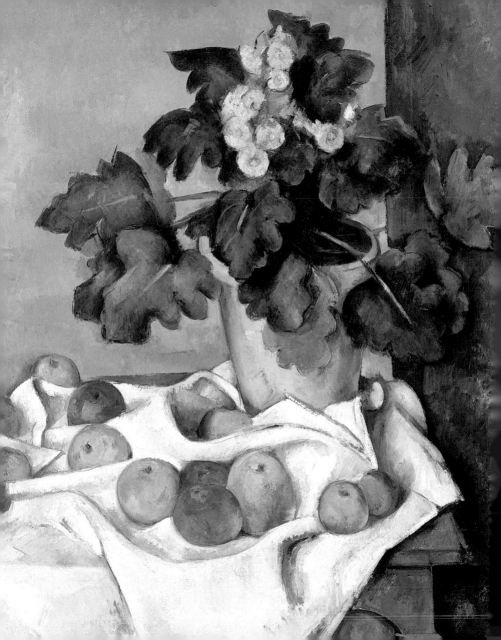

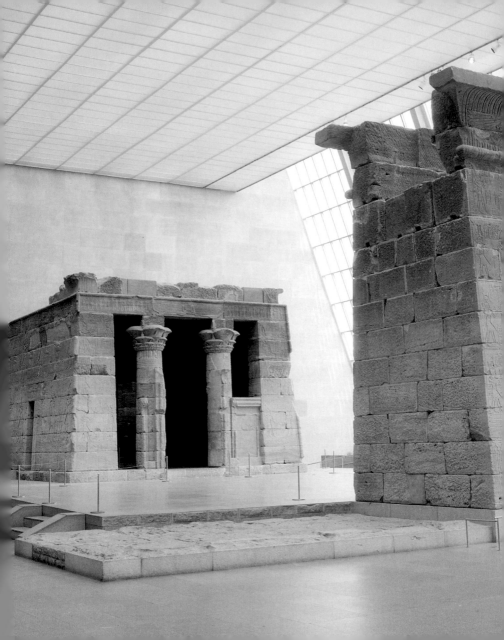

Art is monumental,

The Temple of Dendur
Egyptian (Nubia), Roman period
Aeolian sandstone, L. 82 ft., ca. 15 BC
Given to the United States by Egypt in 1965,
awarded to The Metropolitan Museum of Art in 1967,
and installed in The Sackler Wing in 1978 68.154

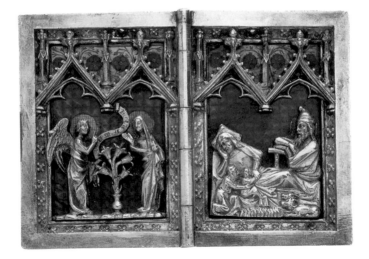

art is miniature.

Diptych with scenes of the Annunciation, Nativity, Crucifixion, and Resurrection
German (probably Cologne), 1300–1325
Silver gilt with translucent and opaque enamels, 2 3/8 x 3 3/8 in.
Gift of Ruth Blumka, 1980 1980.366

Art is restrained,

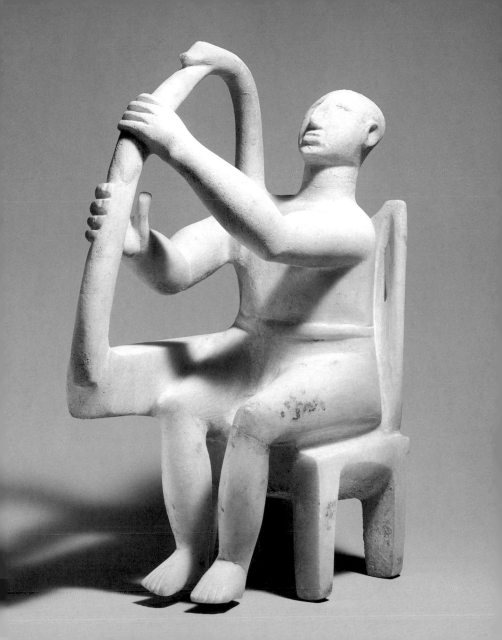

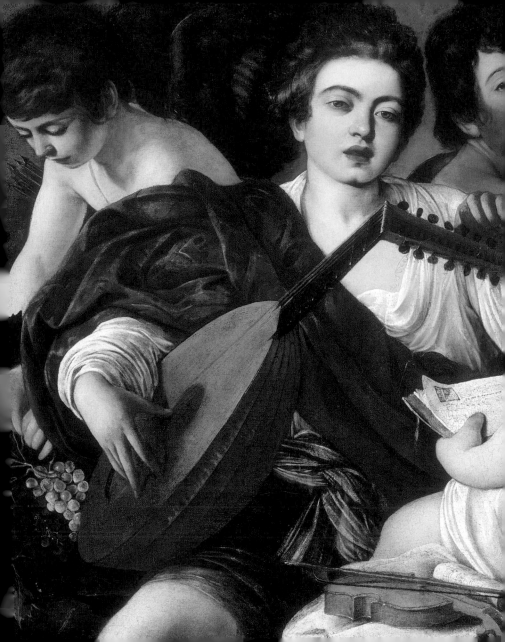

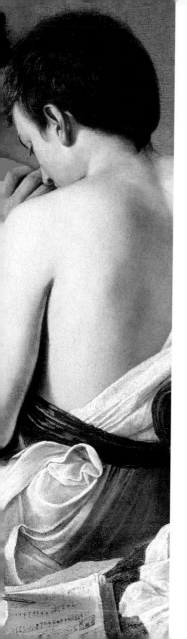

art is sensuous.

The Musicians (detail)
Caravaggio (Michelangelo Merisi), Italian, 1571–1610
Oil on canvas, 36¹/₄ × 46⁵/₈ in., ca. 1595
Rogers Fund, 1952 52.81

Art is useful,

"The Antonius" Violin

Antonio Stradivari, Italian (Cremona), 1644–1737

Maple, spruce, ebony, L. 23 in., 1711

Bequest of Annie Bolton Matthews Bryant, 1933 34.86.1a

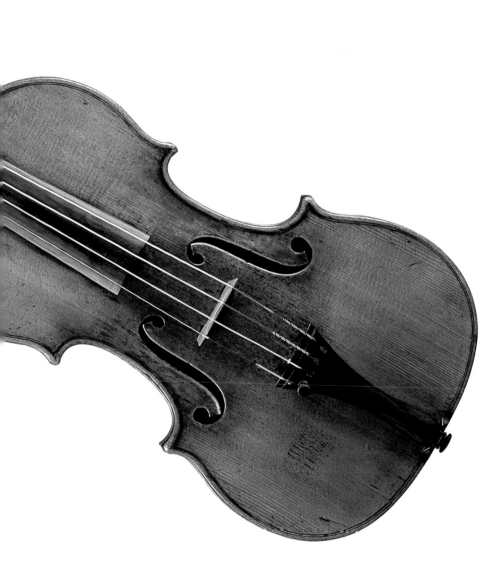

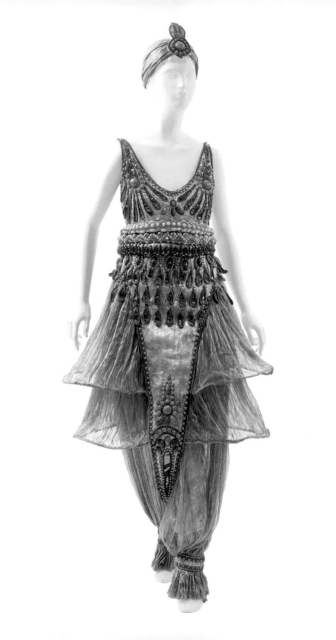

art is whimsical.

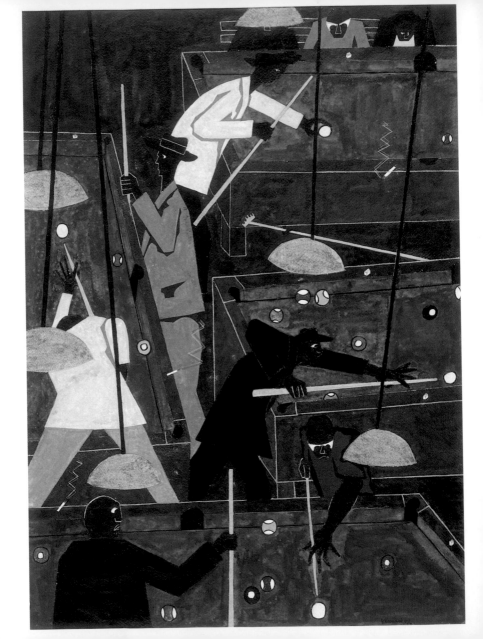

Art is skill,

art is chance.

Four playing cards from a set of fifty-two

South Netherlandish, ca. 1470–80

Pasteboard with pen and ink, tempera, applied gold and silver, $5^3/8 \times 2^3/4$ in.

The Cloisters Collection, 1983 1983.515.1-.52

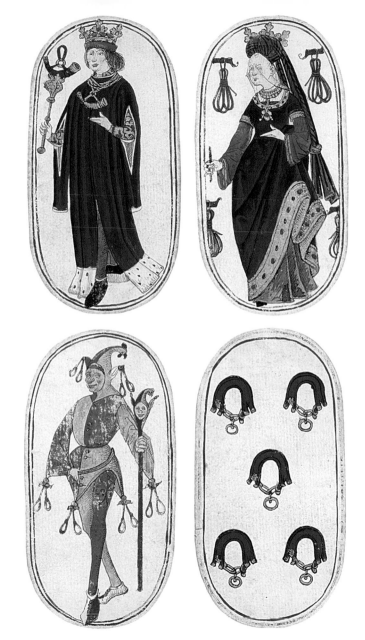

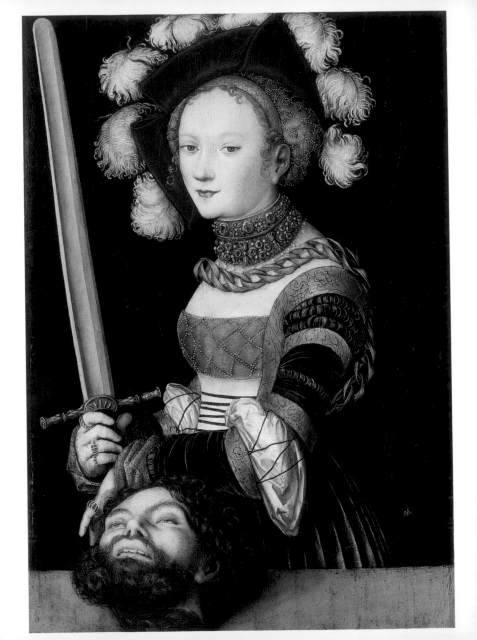

Art is didactic,

art is expressive.

Improvisation 27 (Garden of Love II)

Vasily Kandinsky, French (b. Russia), 1866–1944

Oil on canvas, 47³/₈ × 55¹/₄ in., 1912

Alfred Stieglitz Collection, 1949 49.70.1

© Artists Rights Society (ARS), New York / ADAGP, Paris

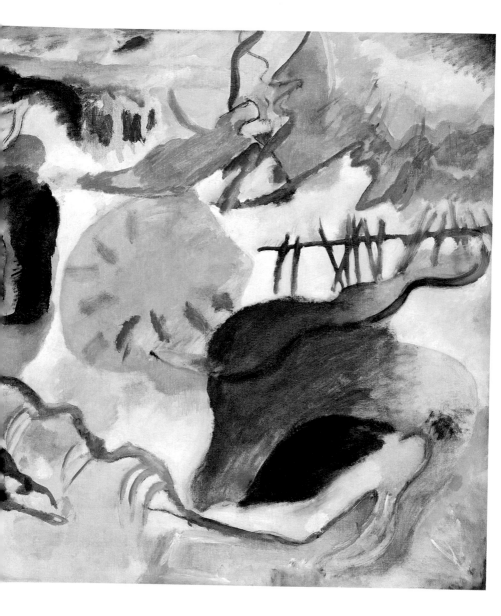

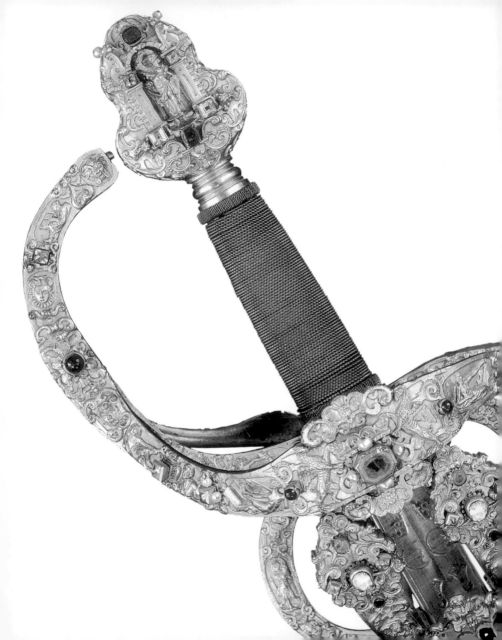

Art is ornamental,

Rapier of Christian II, Elector of Saxony (detail)
German (Dresden), 1606
Hilt by Israel Schuech, German, active 1590–1610
Blade by Juan Martinez, Spanish
Steel, bronze, jewels, gold, enamel, L. 48 in.
Fletcher Fund, 1970 1970.77

art is unadorned.

Statue of a kouros (youth) (detail)
Greek (Attic), Archaic period
Marble, H. 76⅝ in., ca. 590–580 BC
Fletcher Fund, 1932 32.11.1

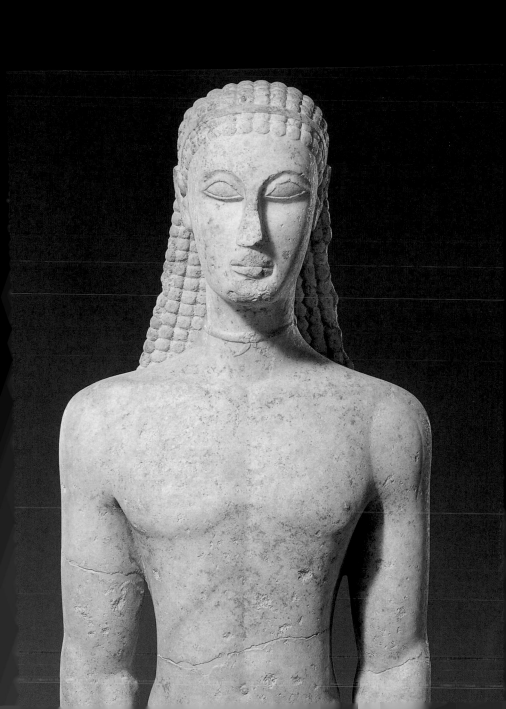

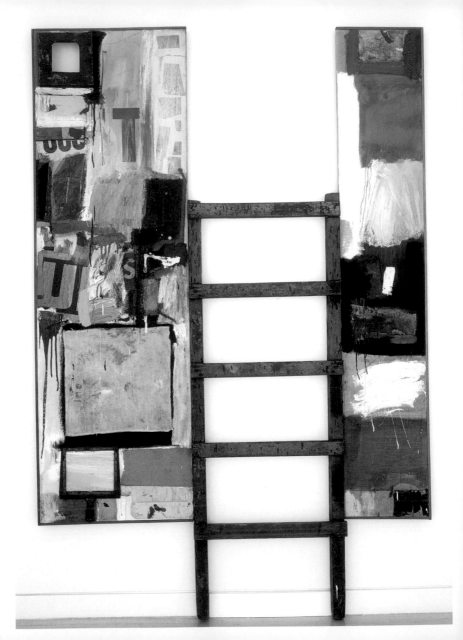

Art is collage,

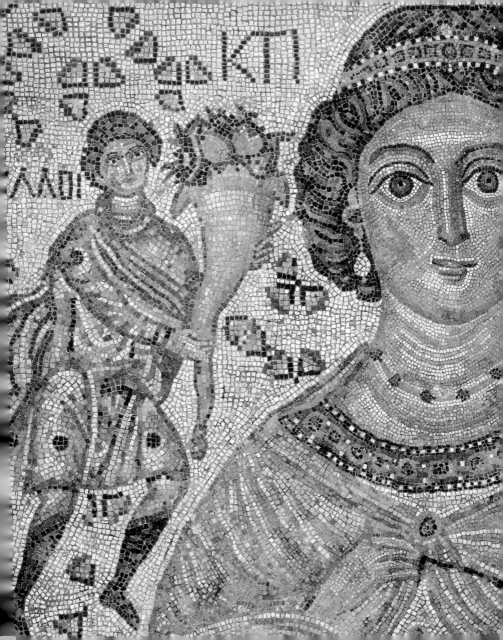

art is mosaic.

Fragment of a floor mosaic with a personification of Ktisis
Byzantine, 500–550 with modern restoration
Marble and glass, $59\,^{1}/_{2}$ x $78\,^{5}/_{8}$ in.
Harris Brisbane Dick Fund and Fletcher Fund, 1998 1998.69
Purchase, Lila Acheson Wallace Gift,
Dodge Fund, and Rogers Fund, 1999 1999.99

Art is rendered,

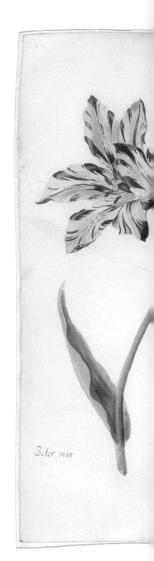

Four Tulips: Boter man (Butter Man), Joncker (Nobleman),
Grote geplumaceerde (The Great Plumed One), and Voorwint (With the Wind)
Jakob Marrel, German, 1613/14–1681
Watercolor on vellum, 13 3/16 × 17 5/16 in., before 1681
Rogers Fund, 1968 68.66

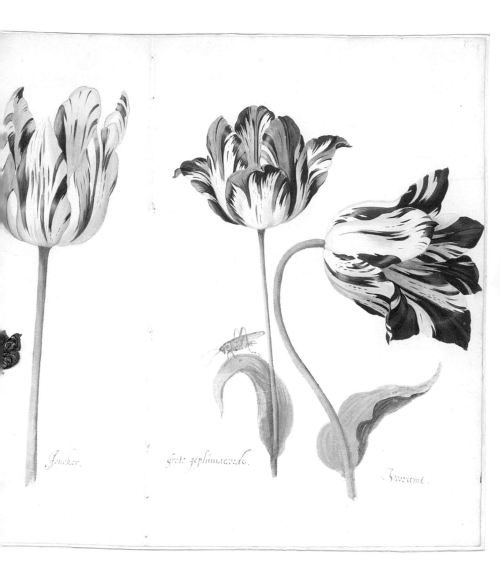

Joncker. *grete geplumaceerde.* *Swartwint.*

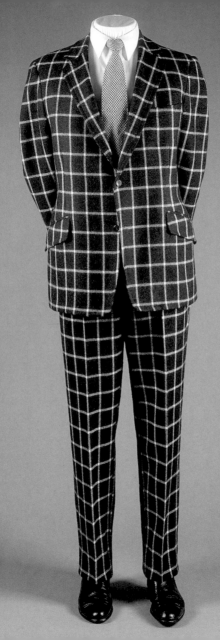

art is stitched.

Art is structured,

Chapter house from Notre-Dame-de-Ponaut

French (Aquitaine), 12th century

Limestone, H. 37 ft. 9 in.

The Cloisters Collection, 1935 35.50

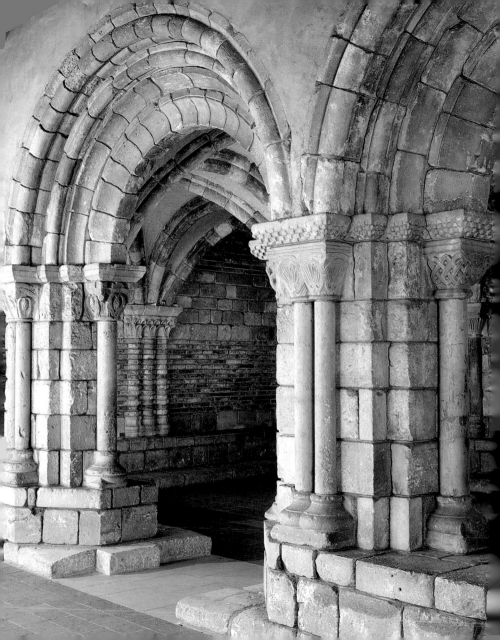

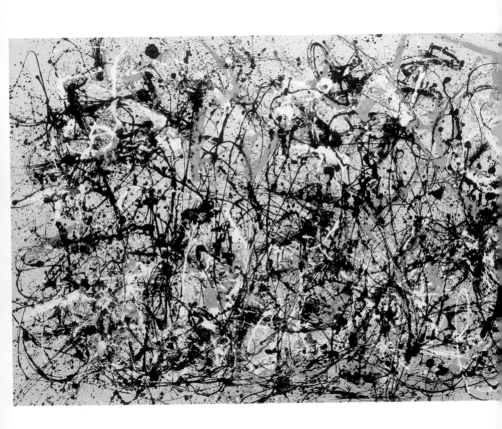

art is dynamic.

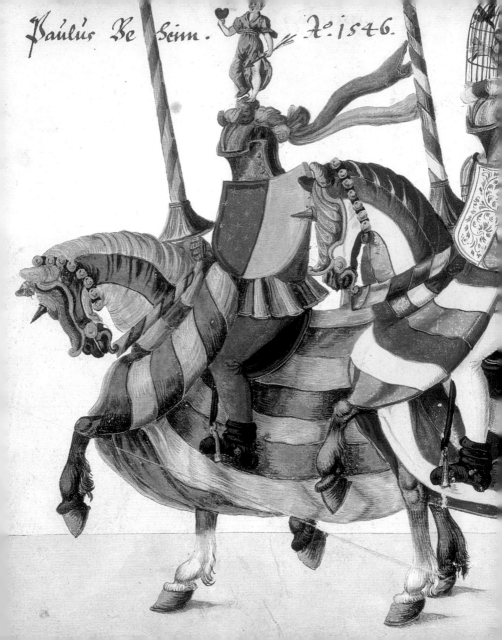

Paulus Be heim. A° 1546.

Art is competition,

Page from a tournament book (detail)
German (Nuremberg), late 16th–mid-17th century
Pen and colored wash on paper
Rogers Fund, 1922 22.229

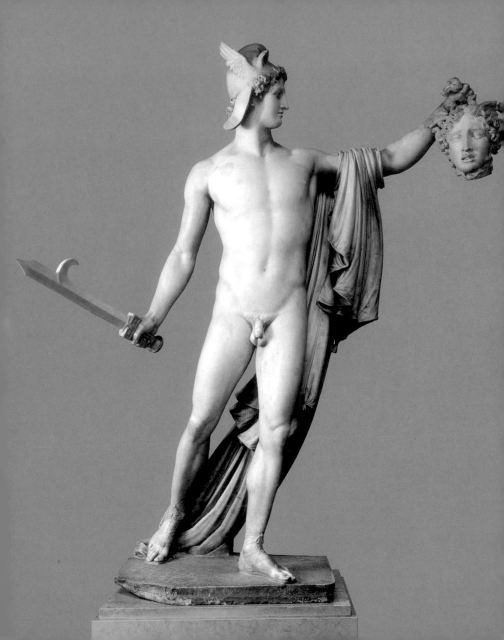

art is conquest.

Perseus with the Head of Medusa
Antonio Canova, Italian (Rome), 1757–1822
Marble, H. 95 1/2 in., 1804–06
Fletcher Fund, 1967 67.110.1

Art is young,

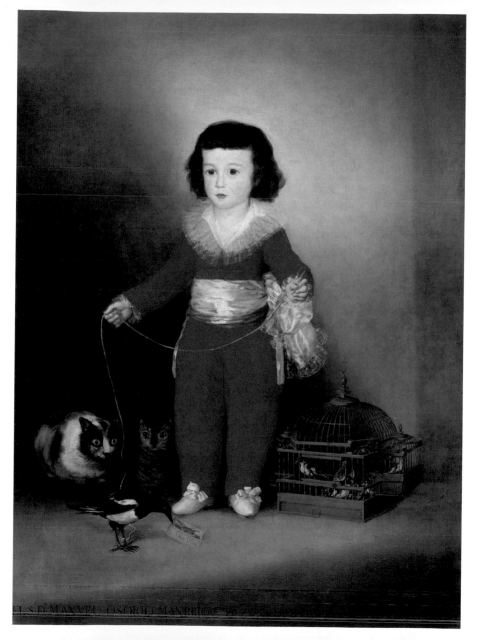

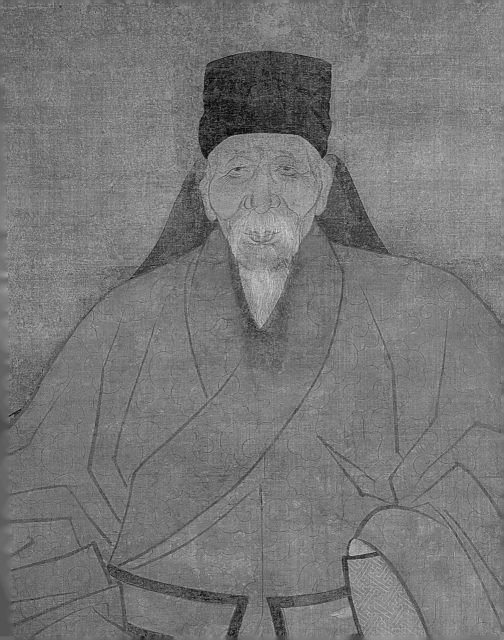

art is old.

Art is figurative,

Hippopotamus
Egyptian, Middle Kingdom (Dynasty 12)
Faience, H. 4⁷/₁₆ in., ca. 1981–1885 BC
Gift of Edward S. Harkness, 1917 17.9.1

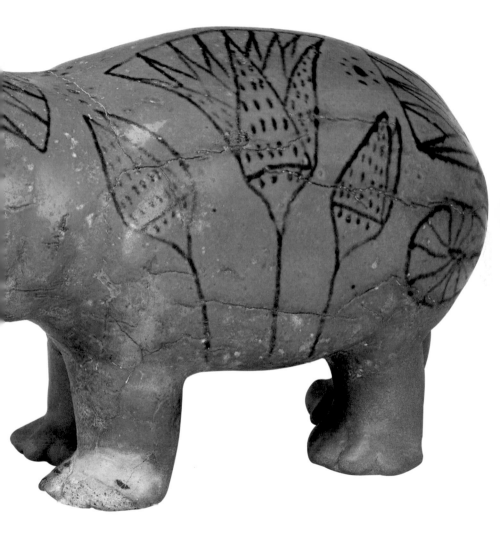

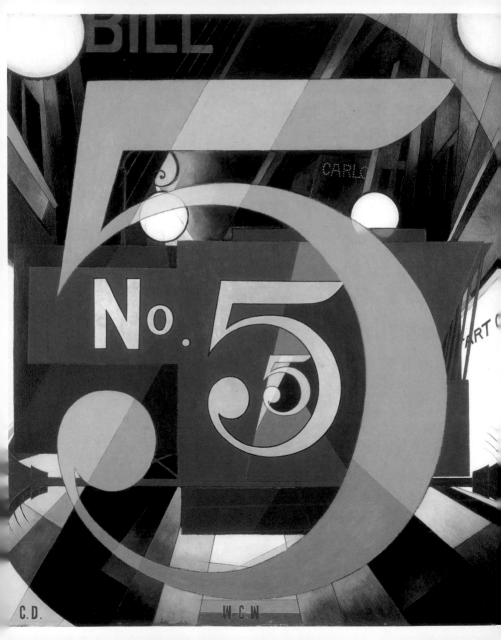

art is abstract.

Art is philosophy,

Aristotle with a Bust of Homer (detail)
Rembrandt van Rijn, Dutch, 1606–1669
Oil on canvas, $56^{1}/_{2} \times 53^{3}/_{4}$ in., 1653
Purchase, special contributions and funds given
or bequeathed by friends of the Museum, 1961 61.198

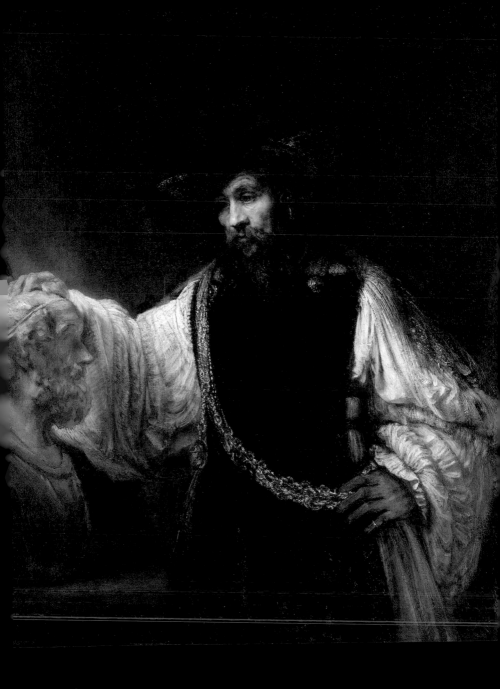

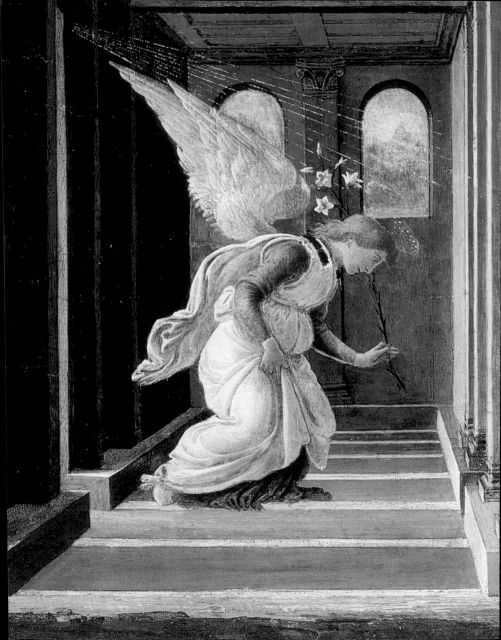

art is belief.

Art is self,

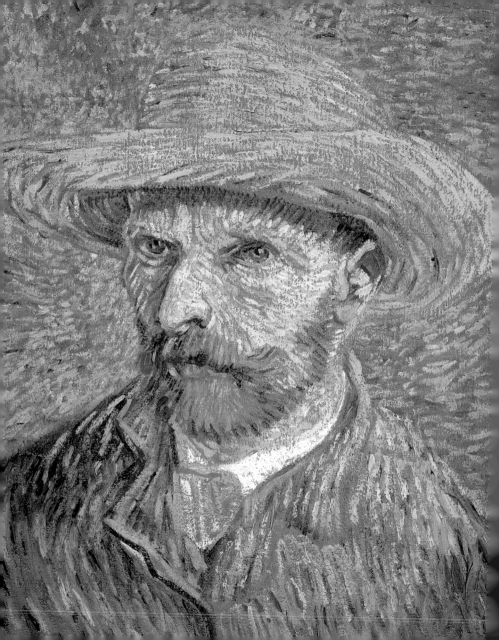

art is madness.

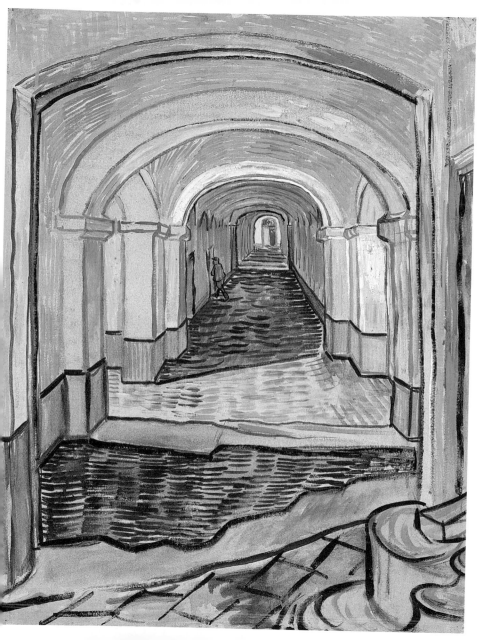

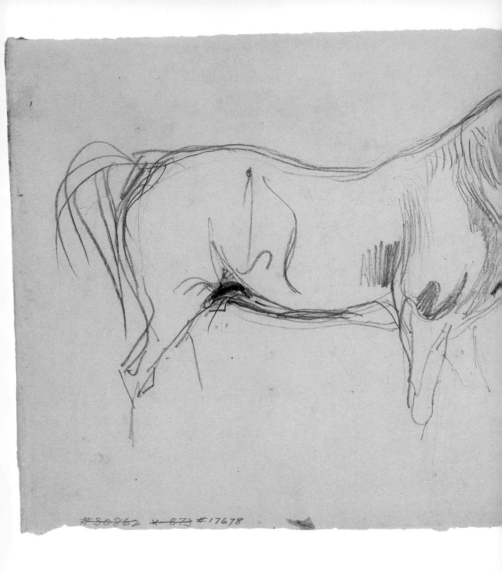

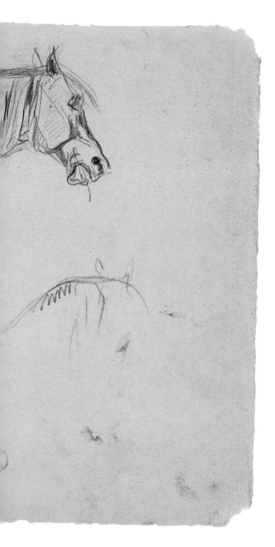

Art is line,

Studies of a Horse in Profile

Eugène Delacroix, French, 1798–1863

Pencil on gray-beige wove paper (probably a sheet from a sketchbook), 5⅝ × 8⅞ in., 1825–31

Robert Lehman Collection, 1975 1975.1.612

art is point.

Gray Weather, Grande Jatte
Georges Seurat, French, 1859–1891
Oil on canvas, 27³/₄ × 34 in., ca. 1886–88
The Walter H. and Leonore Annenberg Collection,
Gift of Walter H. and Leonore Annenberg, 2002,
Bequest of Walter H. Annenberg, 2002 2002.62.3

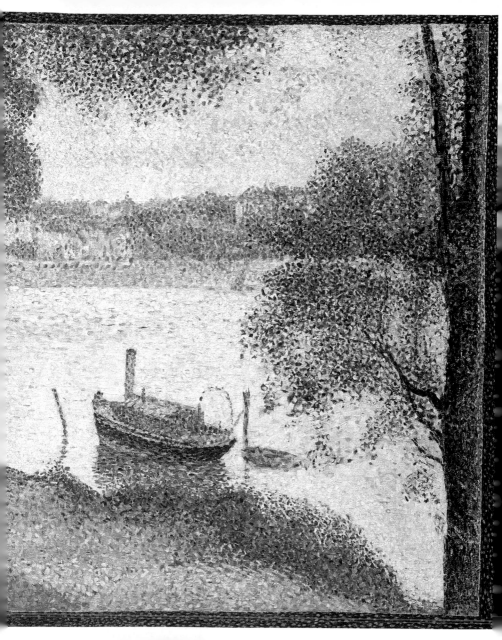

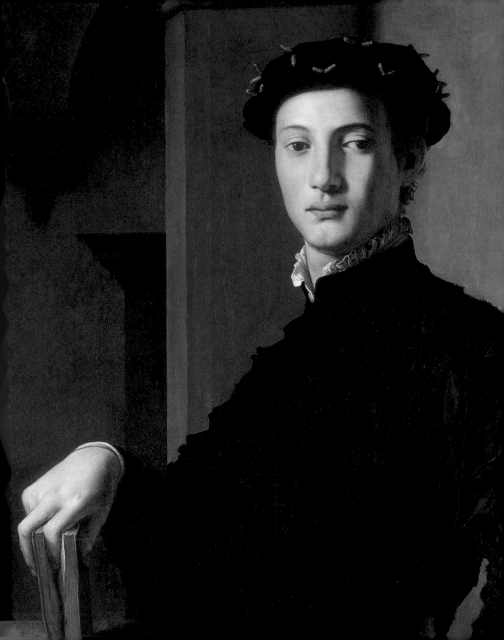

Art is pride,

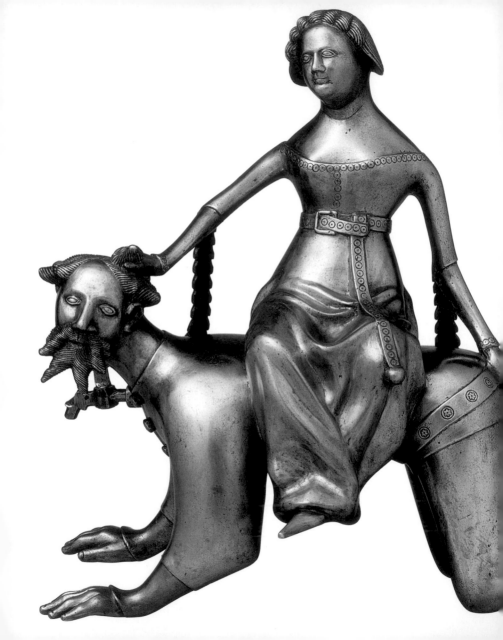

art is humiliation.

Art is lush,

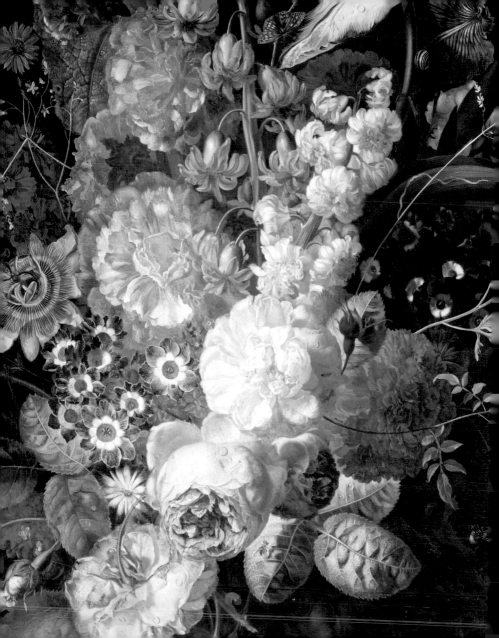

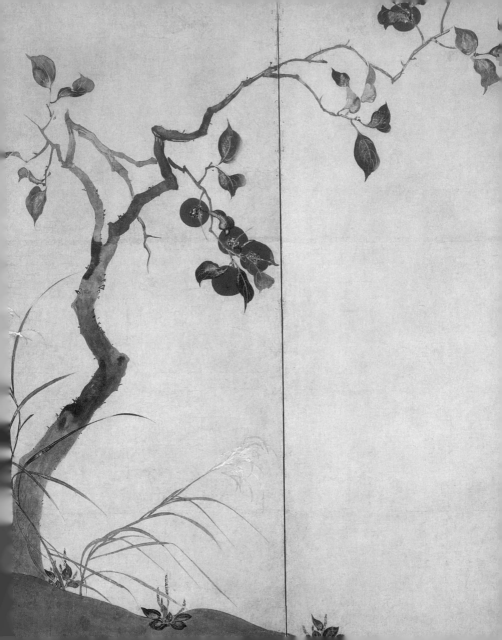

art is spare.

Art is hunger,

The Repast of the Lion (detail)

Henri Rousseau (le Douanier), French, 1844–1910

Oil on canvas, 44³/₄ × 63 in., ca. 1907

Bequest of Sam A. Lewisohn, 1951 51.112.5

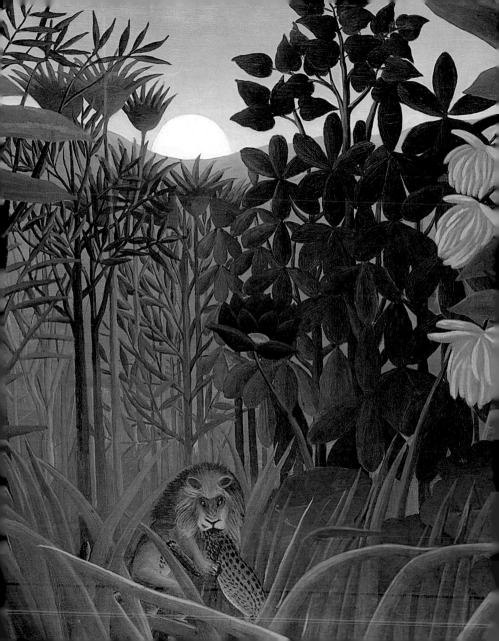

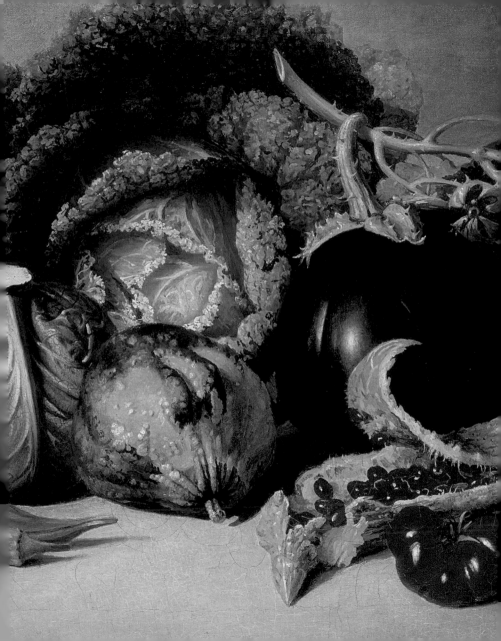

art is nourishment.

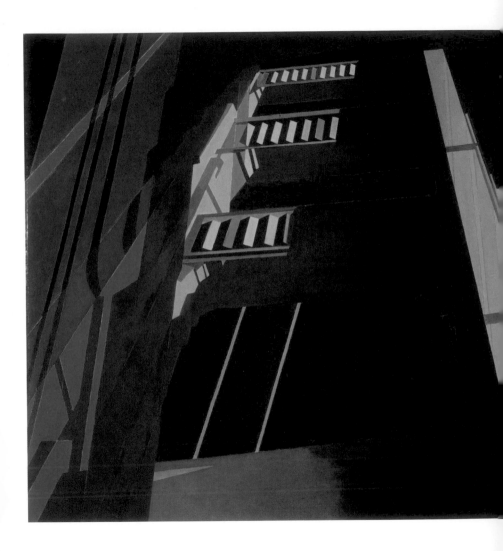

Art is precision,

art is juxtaposition.

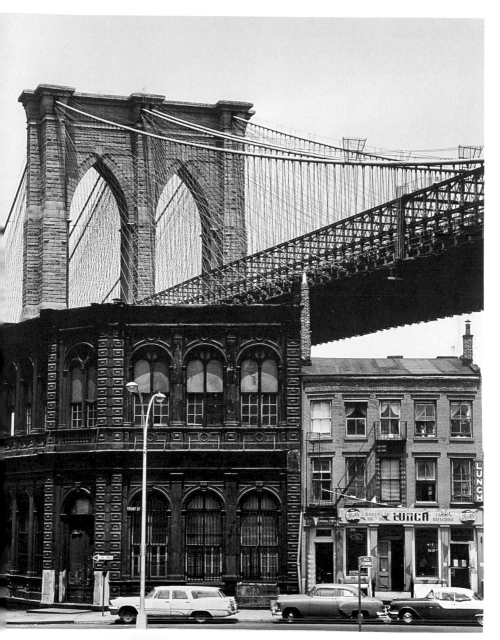

Art is saintly,

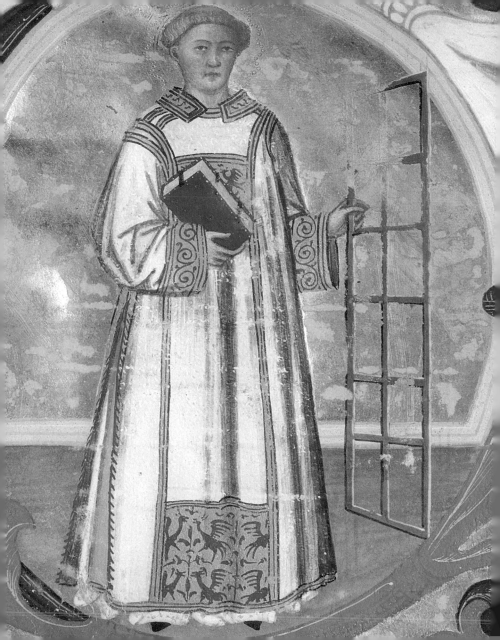

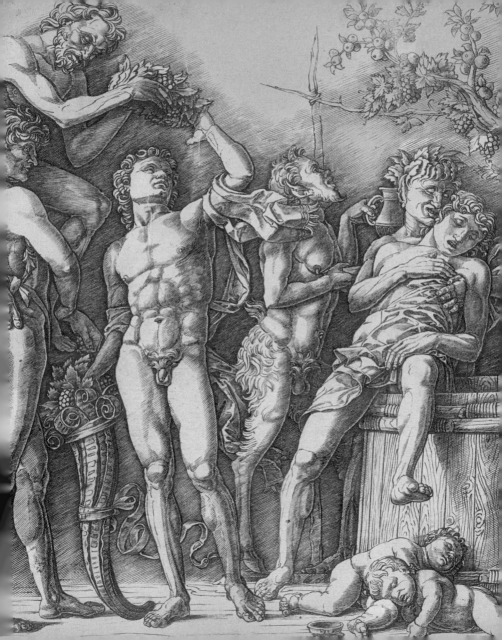

art is sinful.

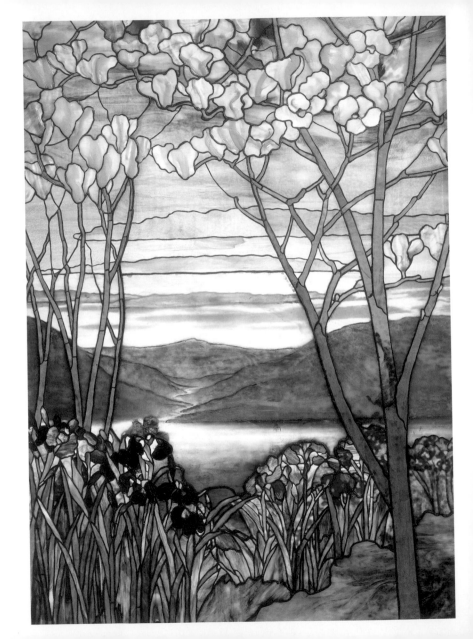

Art is translucent,

art is solid.

Limestone sarcophagus: the Amathus sarcophagus

Cypriot, Archaic period

Limestone, L. 93 ⅛ in., 2nd quarter 5th century BC

The Cesnola Collection, Purchased by subscription, 1874–76 74.51.2453

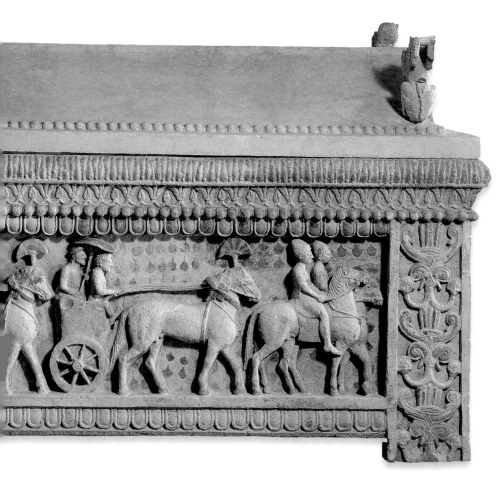

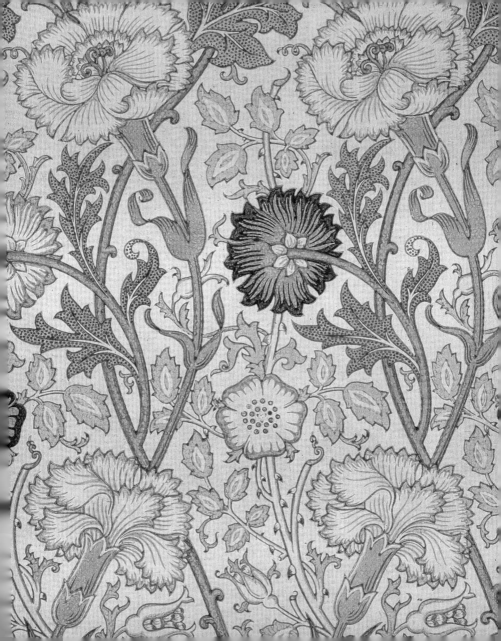

Art is on a wall,

art is in a closet.

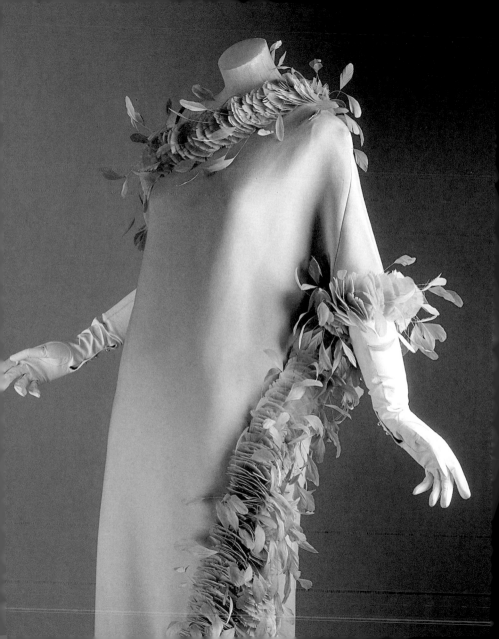

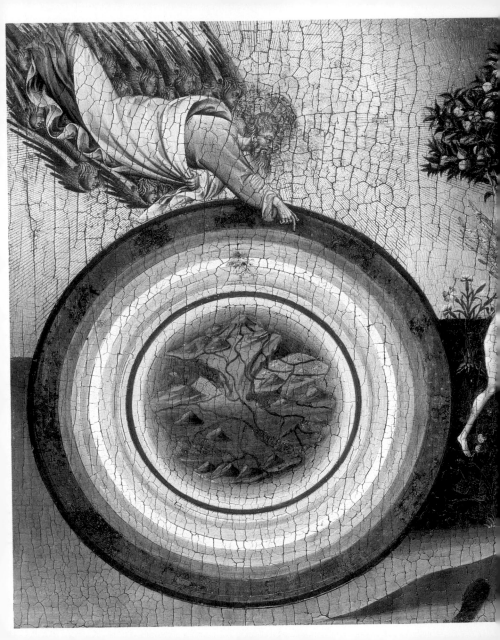

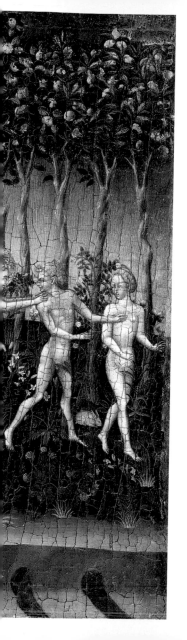

Art is creation,

The Creation of the World and the Expulsion from Paradise
Giovanni di Paolo, Italian (Siena), ca. 1400–1482
Tempera and gold on wood, 18¹/₄ × 20¹/₂ in., 1445
Robert Lehman Collection, 1975 1975.1.31

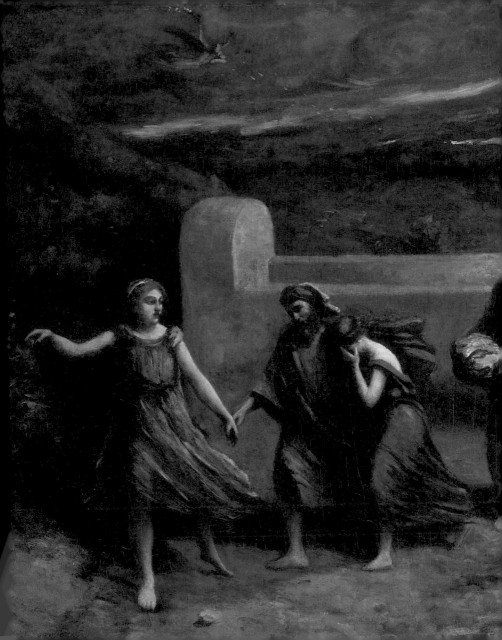

art is destruction.

Art is angular,

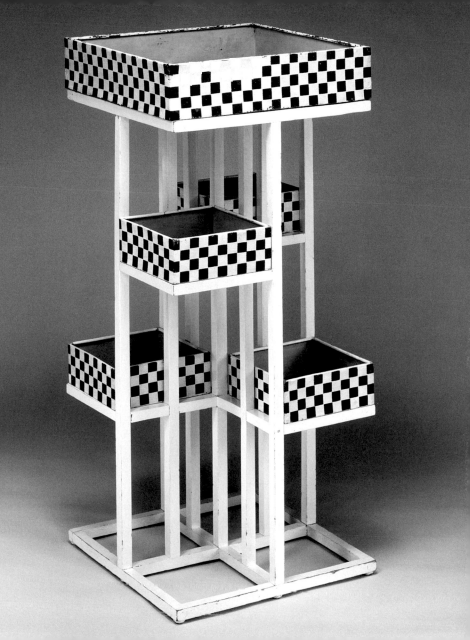

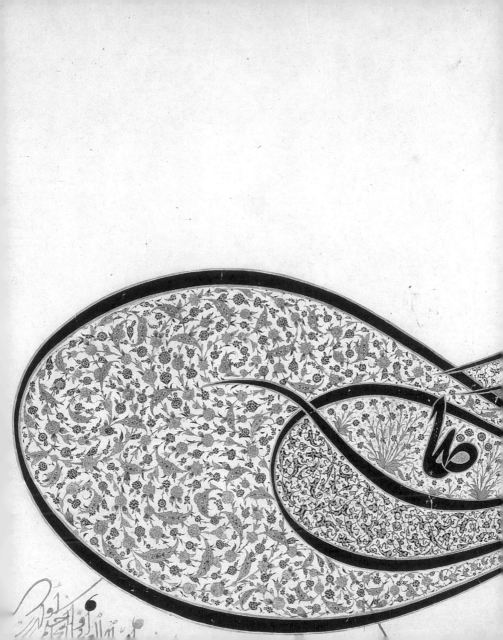

art is sinuous.

Tughra (Official Signature) of Sultan Suleiman the Magnificent (r. 1520–1566) (detail)
Turkey, Ottoman period
Ink, opaque watercolor, and gold on paper, 20¹/₈ × 25³/₈ in, ca. 1555
Rogers Fund, 1938 38.149.1

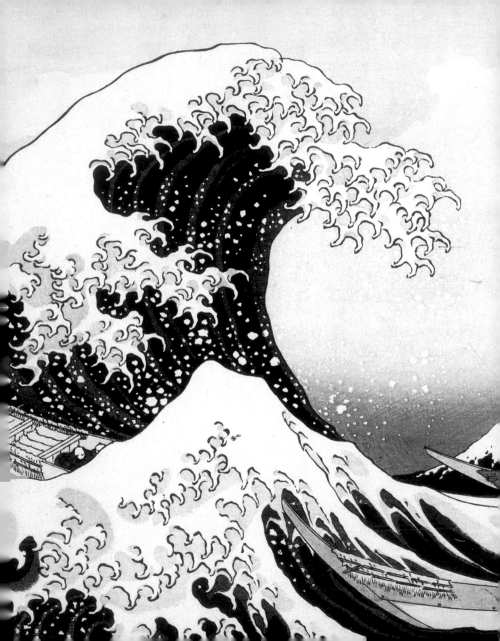

Art is printed,

art is painted.

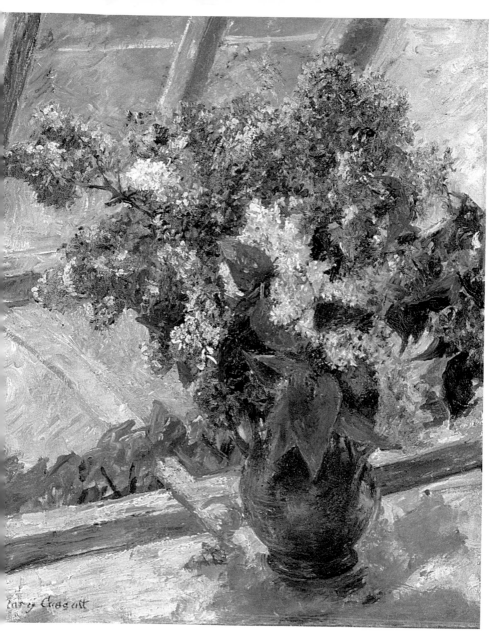

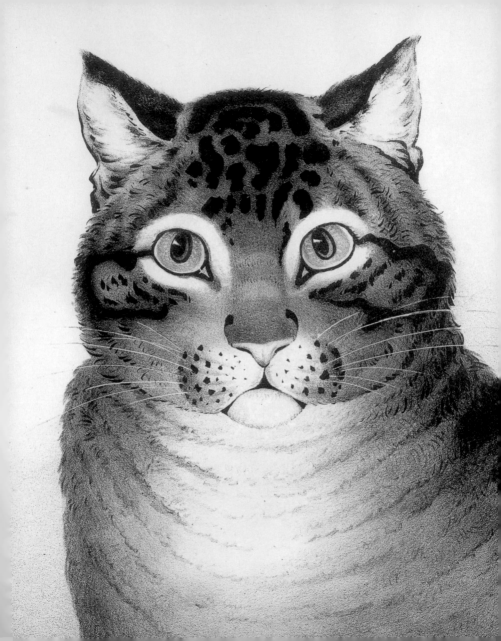

Art is real,

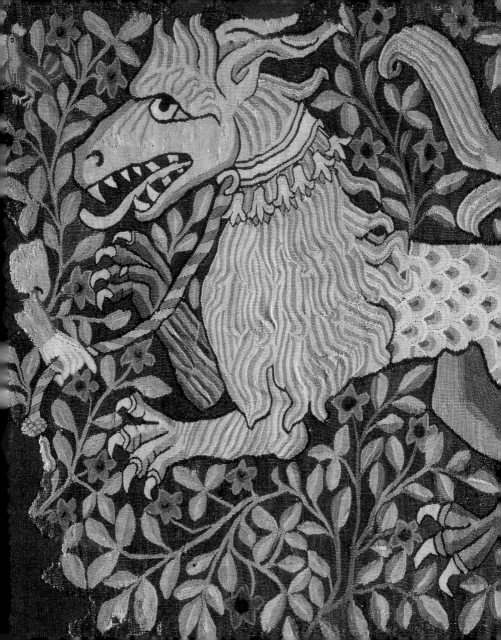

art is imaginary.

Fragment of a tapestry or wall hanging
Swiss (Basel), ca. 1420–30
Tapestry weave: wool on linen, 33 7/16 × 29 1/2 in.
The Cloisters Collection, 1990 1990.211

Art is sacred,

Mosque lamp for the mausoleum of Amir Aydakin al-'Ala'i al-Bunduqdar
Egypt (probably Cairo), Mamluk period (1250–1517)
Glass; blown, folded foot; applied handles; enameled and gilded, H. 10 3/8 in., ca. 1285
Gift of J. Pierpont Morgan, 1917 17.190.985

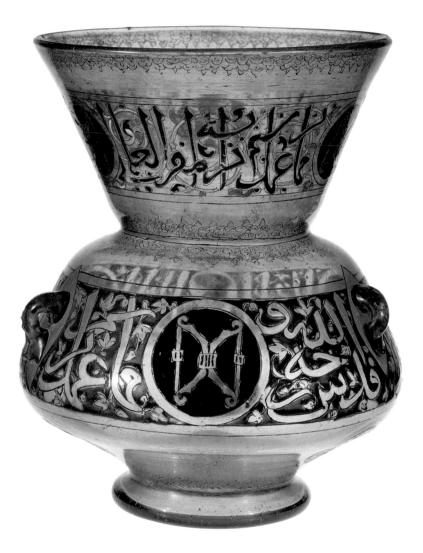

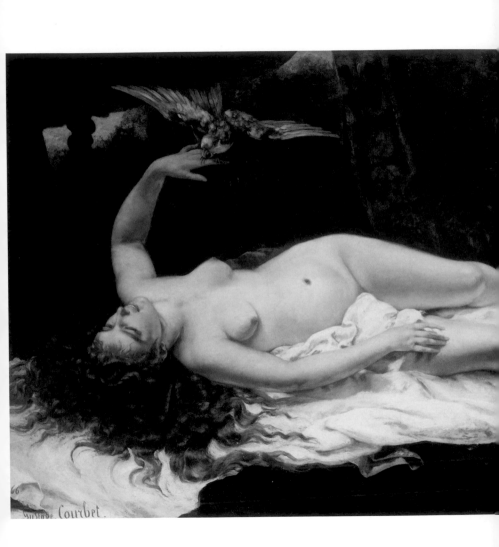

art is profane.

Art is regal,

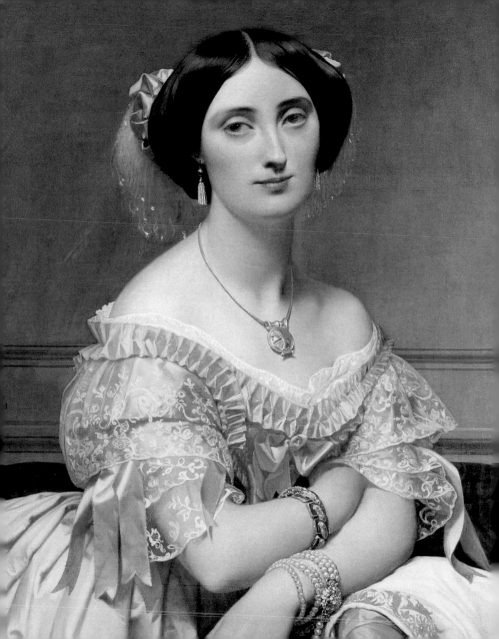

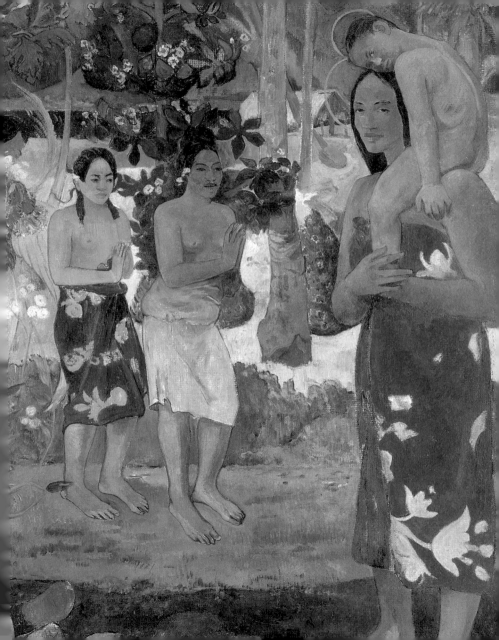

art is humble.

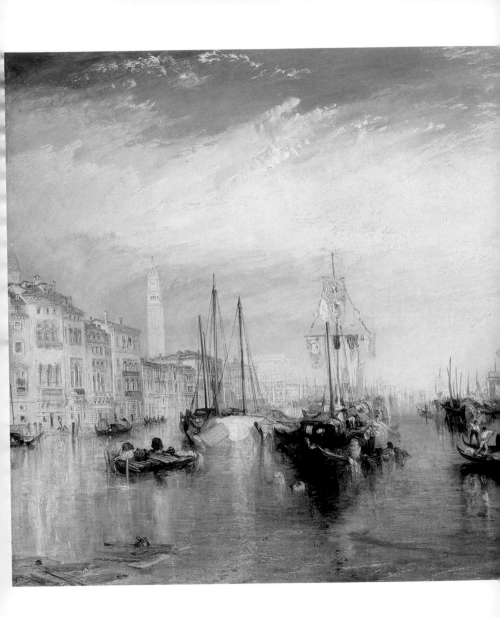

Art is seascape,

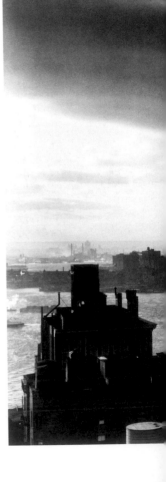

art is cityscape.

Financial District, From the Hotel Bossert
Samuel H. Gottscho, American, 1875–1971
Gelatin silver print, 6⁹/₁₆ × 9⁷/₁₆ in., 1933, printed later
Purchase, Florance Waterbury Bequest, 1970 1970.660.11

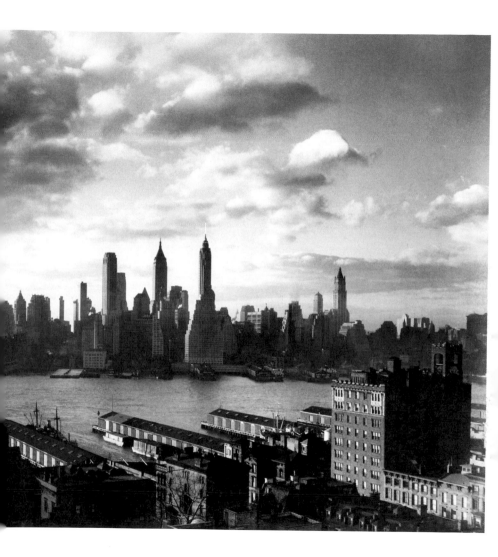

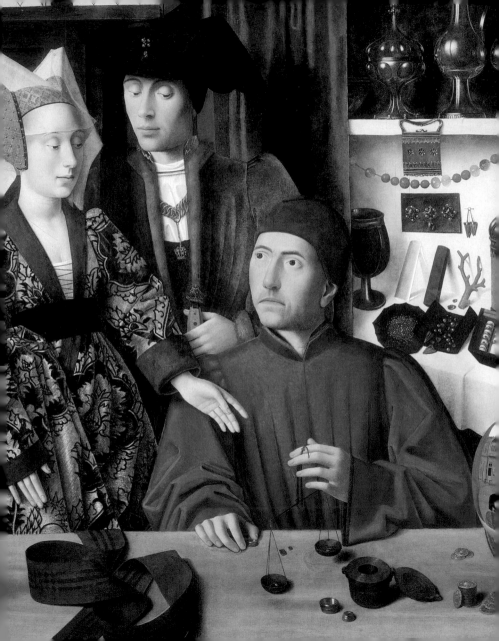

Art is narrative,

A Goldsmith in His Shop, Possibly Saint Eligius (detail)
Petrus Christus, Netherlandish, active by 1444–died 1475/76
Oil on oak panel, 39³/₈ × 33¹/₄ in., 1449
Robert Lehman Collection, 1975 1975.1.110

art is myth.

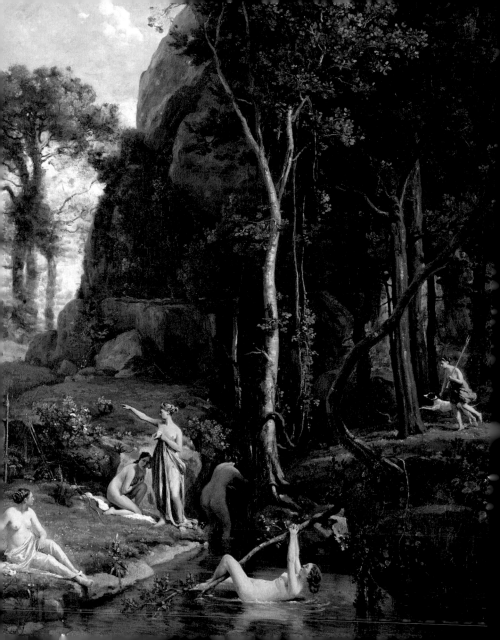

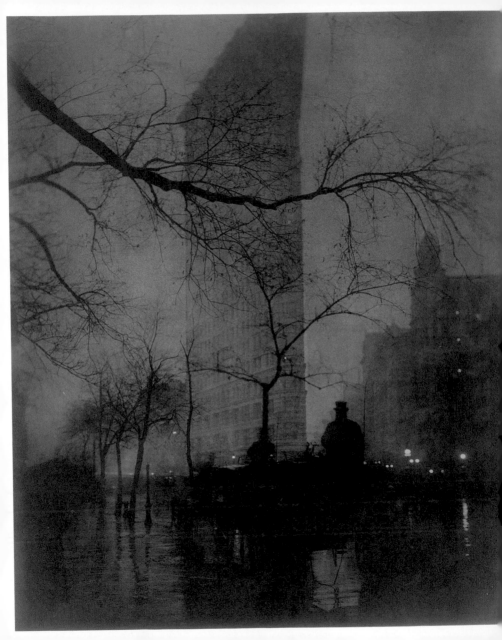

Art is atmospheric,

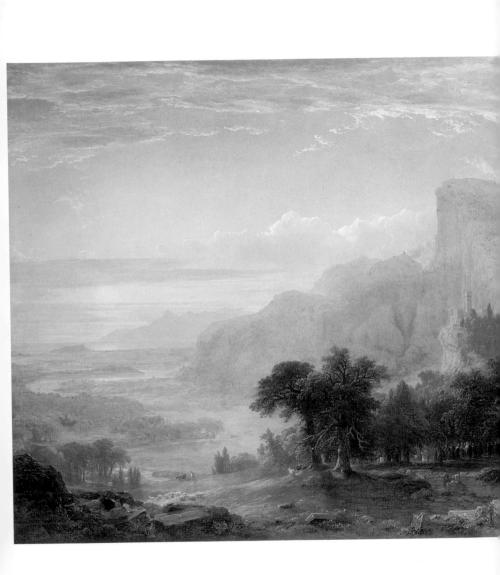

art is ethereal.

Landscape—Scene from "Thanatopsis"
Asher Brown Durand, American, 1796–1886
Oil on canvas, 39 1/2 × 61 in., 1850
Gift of J. Pierpont Morgan, 1911 11.156

Art is a glance,

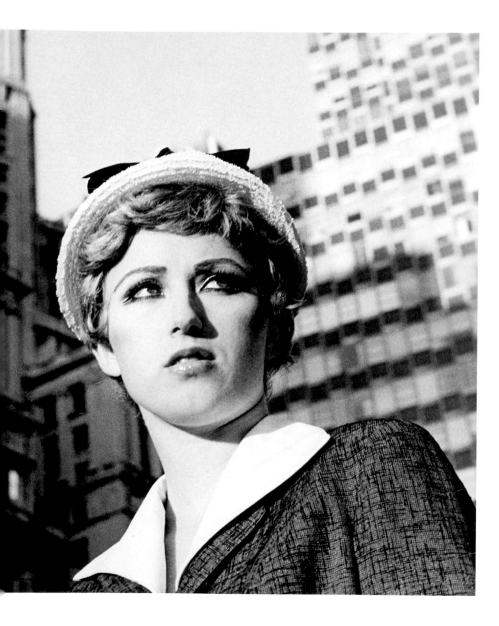

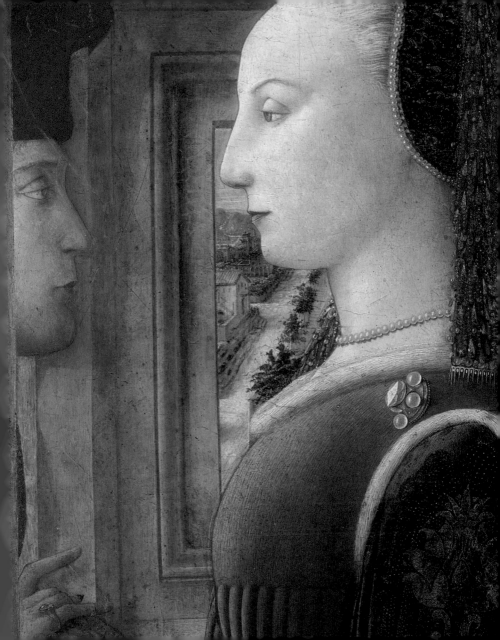

art is a gaze.

Art is instruction,

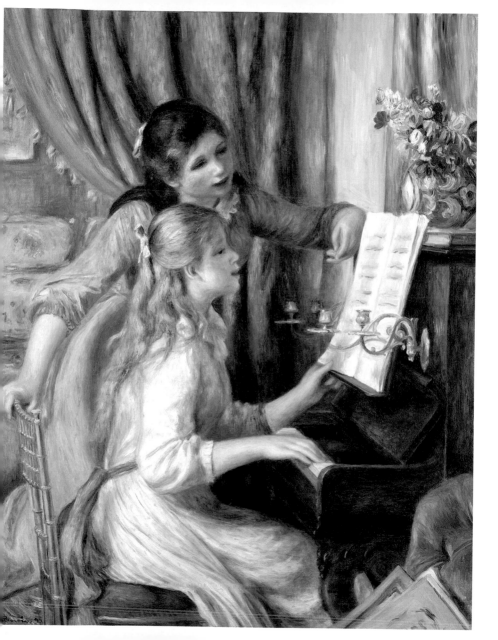

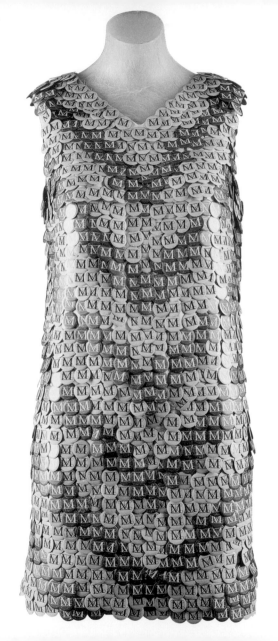

art is construction.

Art is documentary,

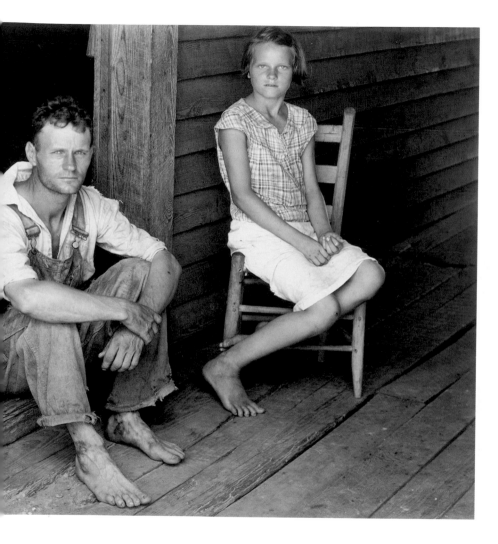

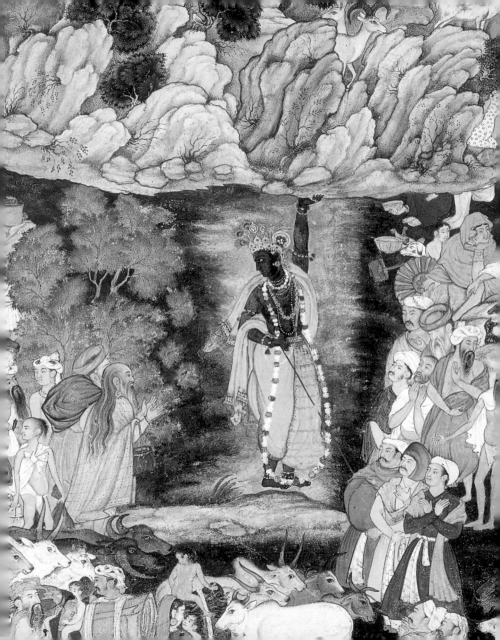

art is legend.

Art is embroidered,

Textile with animals, birds, and flowers
Eastern Central Asia, late 12th–14th century
Silk embroidery on plain-weave silk, 14 5/8 × 14 7/8 in.
Rogers Fund, 1988 1988.296

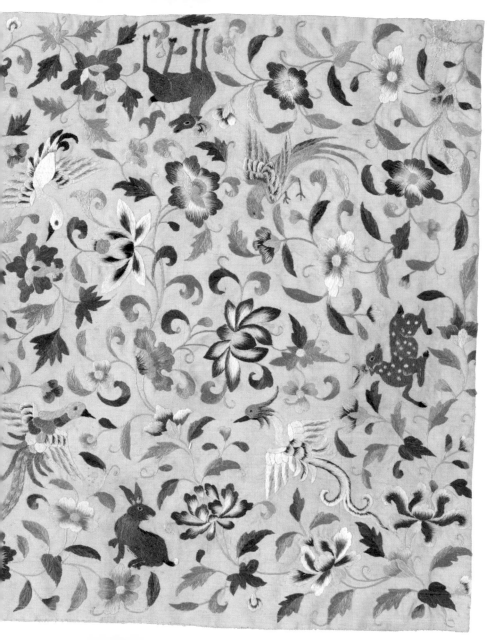

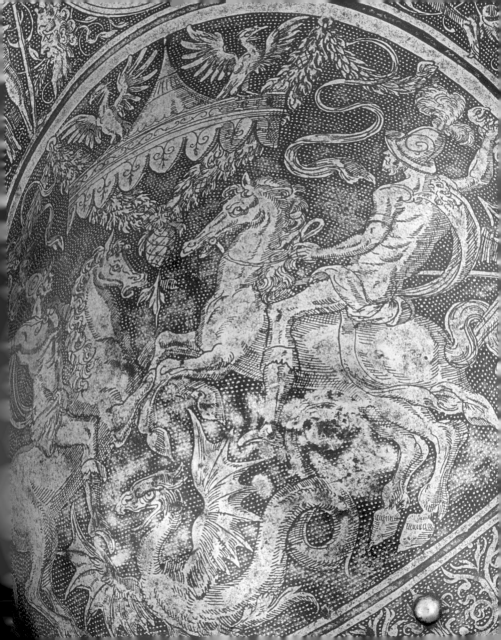

art is etched.

Comb Morion (detail)
German (Brunswick?), ca. 1560–65
Etched steel, H. 12 1/2 in.
Purchase, The Sulzberger Foundation Inc. and
Ronald S. Lauder Gifts, 1999 1999.62

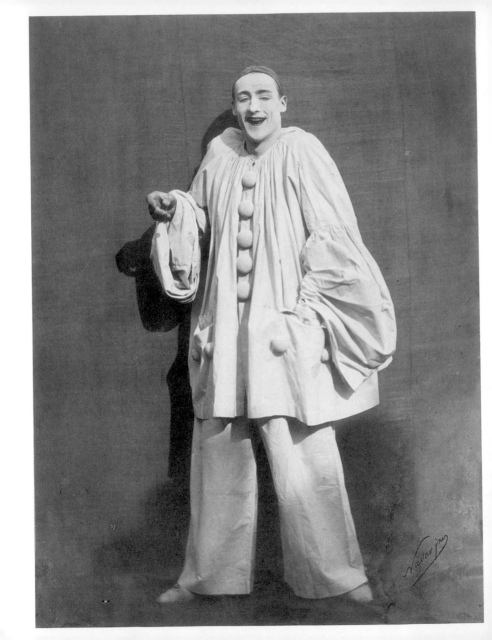

Art is comedy,

art is tragedy.

Grave stele of a little girl (detail)
Greek, classical, ca. 450–440 BC
Marble, Parian, H. 31 1/2 in.
Fletcher Fund, 1927 27.45

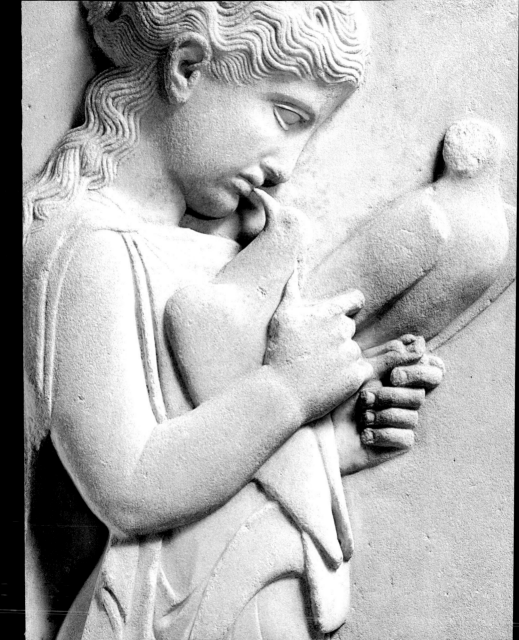

Art is bejeweled,

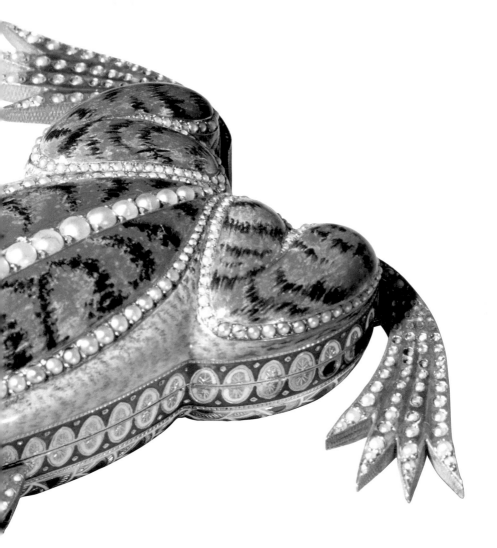

Automaton
Switzerland, ca. 1820
Gold, enamel, diamond, ruby, L. 2⁷/₁₆ in.
Gift of Murtogh D. Guinness, 1976 1976.285.2a–c

art is austere.

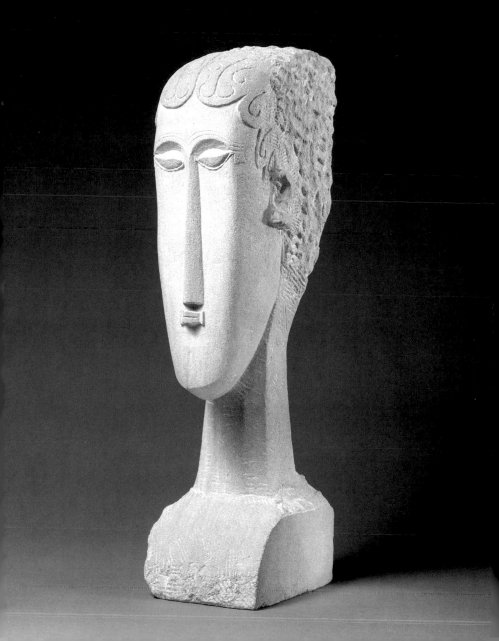

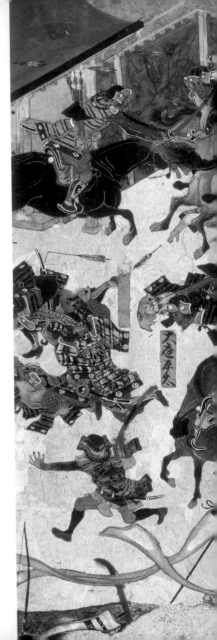

Art is war,

The Battles of the Hôgen and Heiji Eras (detail)
Japanese, Edo period (1615–1868)
Pair of six-panel folding screens; ink, color, and gold on paper,
5 ft. 1 in. × 11 ft. 8 in., 17th century
Rogers Fund, 1957 57.156.4, .5

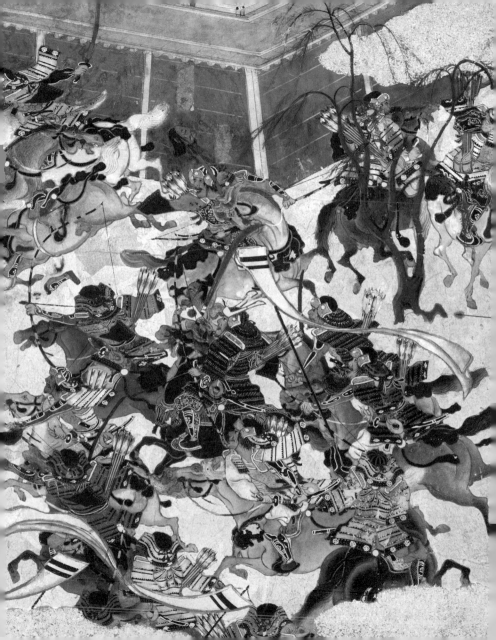

art is victory.

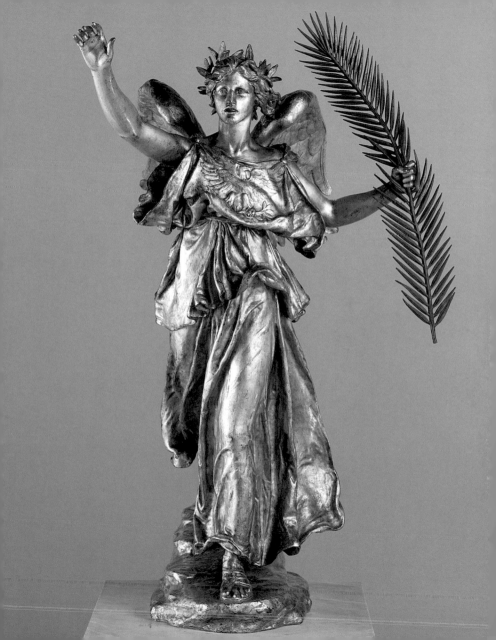

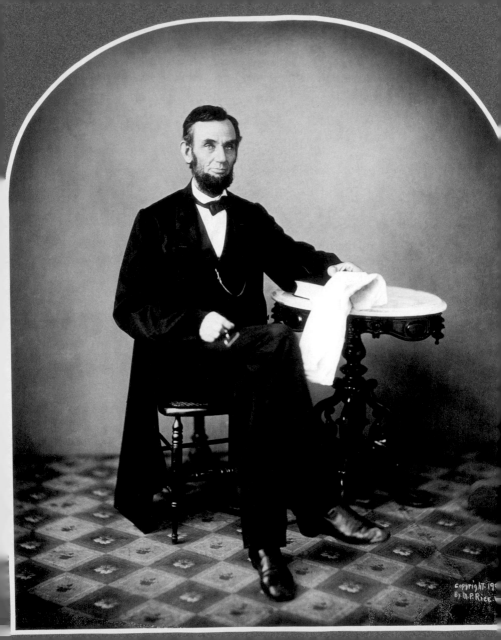

Art is honesty,

Abraham Lincoln
Alexander Gardner, American (b. Scotland), 1821–1882
Gelatin silver print, 18 × 15 in., 1863, printed 1901
Warner Communications Inc. Purchase Fund, 1976 1976.627.1

art is chicanery.

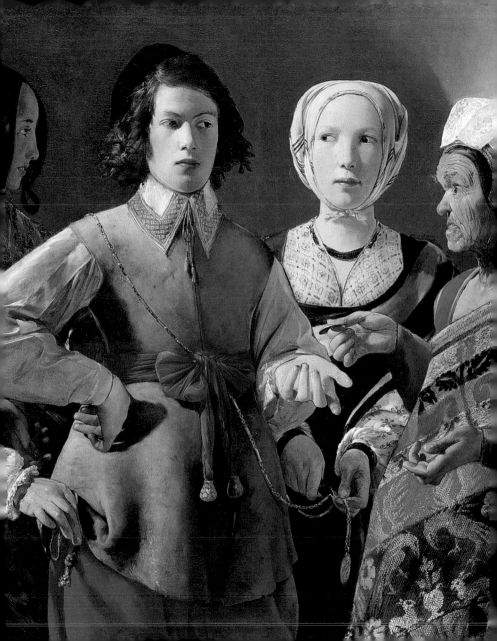

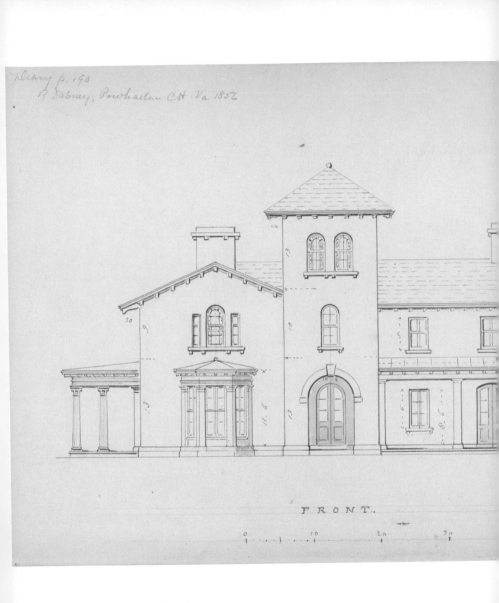

FRONT.

0 10 20 30

Art is drafted,

art is sculpted.

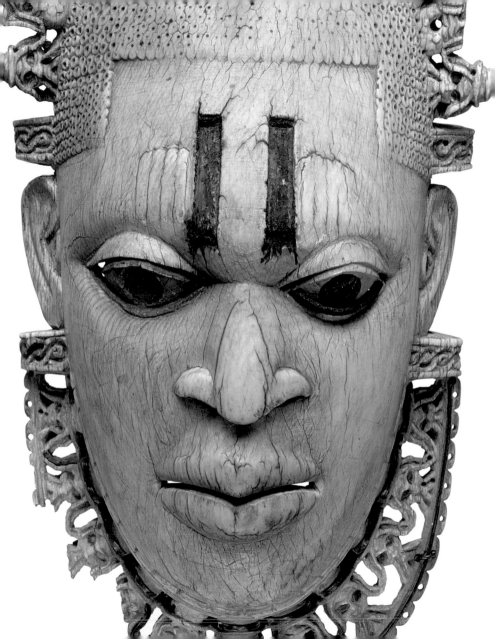

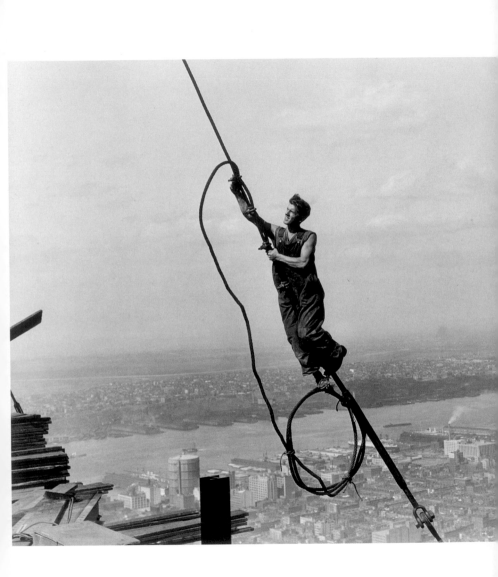

Art is interpretation,

art is another
interpretation.

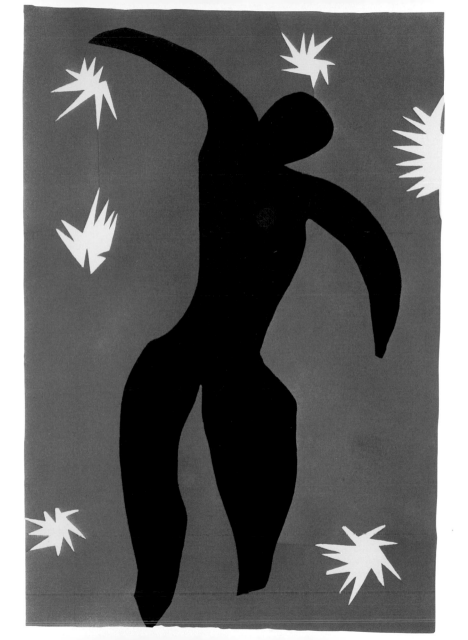

Art is common,

Thurber's Preserved Pitted Red Cherries
American, 19th century
Chromolithographic canning label
The Jefferson R. Burdick Collection, Gift of Jefferson R. Burdick Burdick 18 p.7(2)

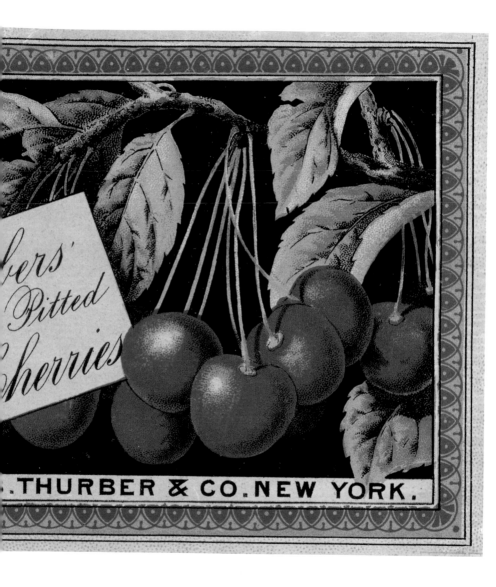

art is sublime.

The Titan's Goblet (detail)
Thomas Cole, American, 1801–1848
Oil on canvas, 19³/₈ × 16¹/₈ in., 1833
Gift of Samuel P. Avery Jr., 1904 04.29.2

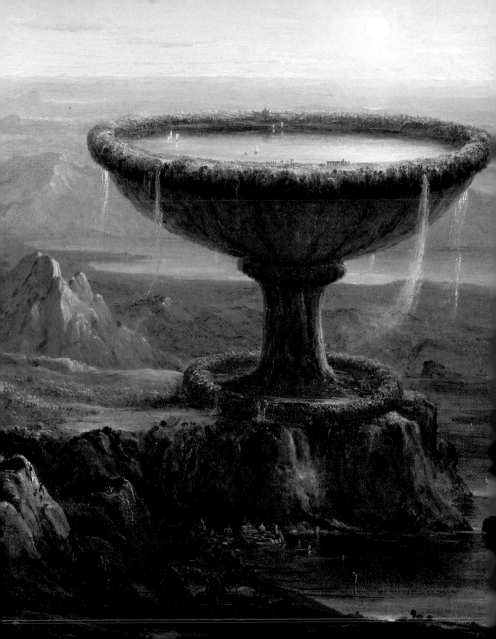

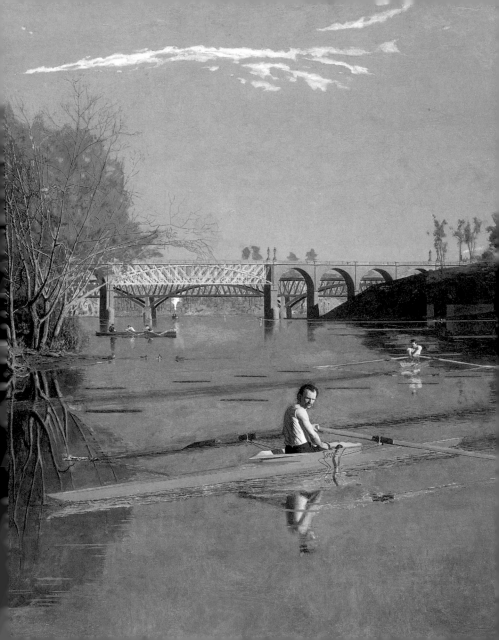

Art is sport,

art is theater.

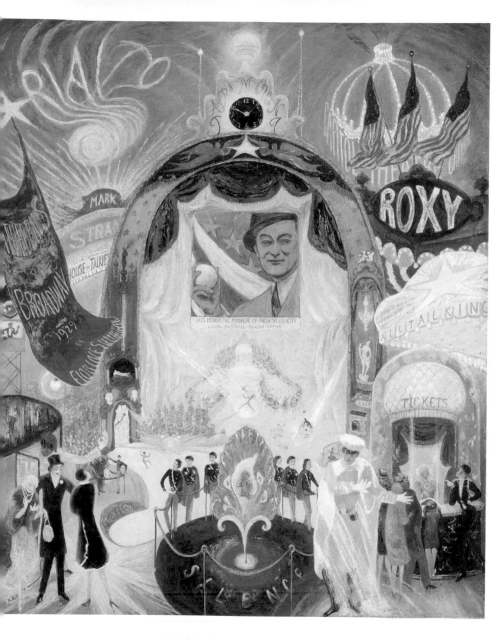

RIALTO

MARK
STRAND
HOUSE OF TALKIES

BROADWAY
1929
by
FLORINE STETTHEIMER

ROXY

HIS HONOR THE MAYOR OF NEW YORK CITY
LOCAL BASEBALL SEASON OPENS

ALL TALL KING

TICKETS

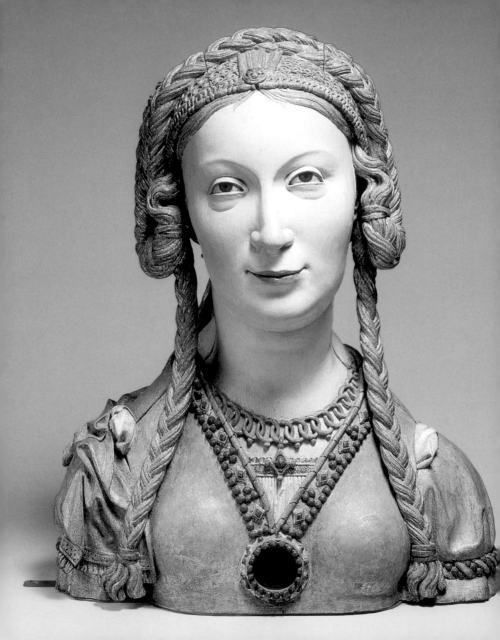

Art is pious,

art is provocative.

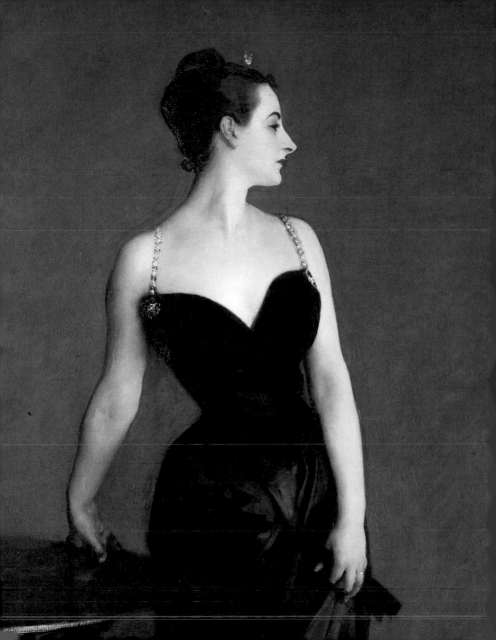

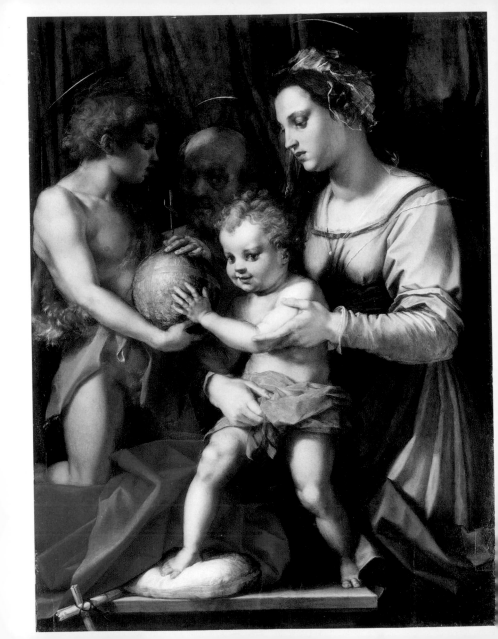

Art is mannered,

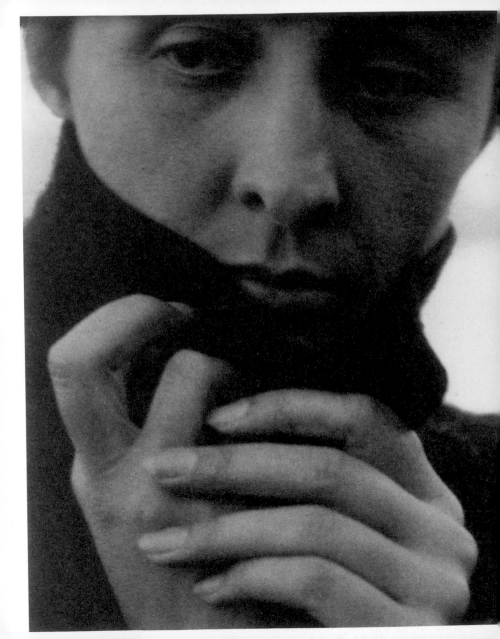

art is photographic.

Georgia O'Keeffe
Alfred Stieglitz, American, 1864–1946
Palladium print, $4^5/8 \times 3^9/16$ in., 1918
Gift of Georgia O'Keeffe, through the generosity of
The Georgia O'Keeffe Foundation and Jennifer and Joseph Duke, 1997
1997.61.25

Art is a journey,

Journey to Abydos, Tomb of Pairy (detail)

Egyptian, New Kingdom (Dynasty 18)

Tempera on paper, facsimile: 11 x 28¹/8 in., ca. 1390–1352 BC

Rogers Fund, 1930 30.4.96

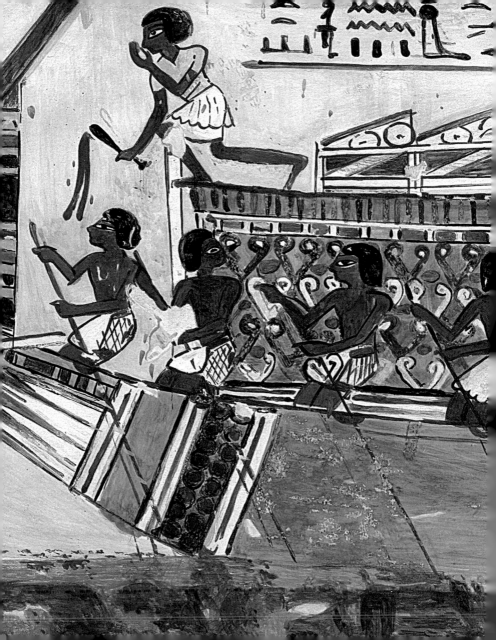

art is an adventure.

Untitled (Cowboy)
Richard Prince, American, b. 1949
Chromogenic print, 50 x 70 in., 1989
Purchase, The Horace W. Goldsmith Foundation Gift through Joyce and
Robert Menschel and Jennifer and Joseph Duke Gift, 2000 2000.272
© Richard Prince

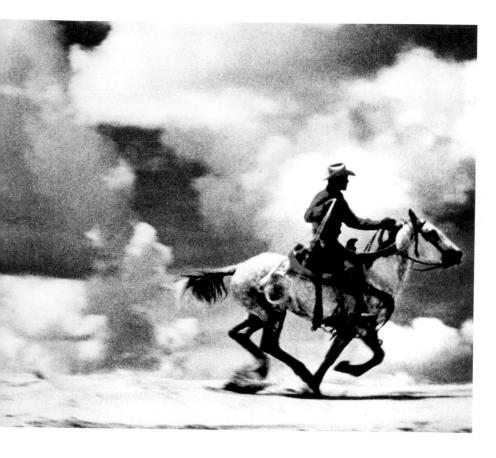

Art is warm,

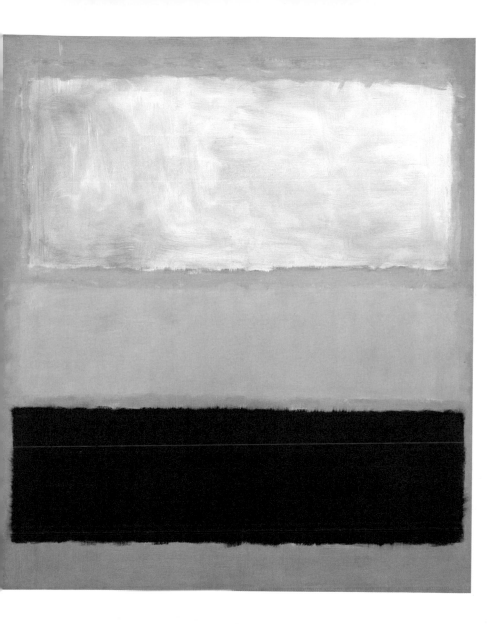

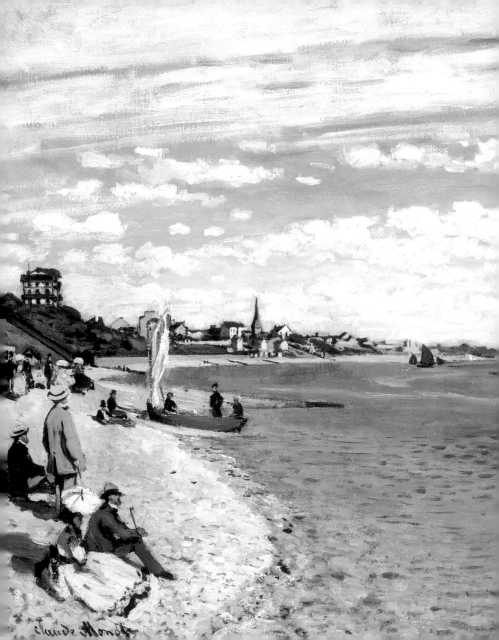
Claude Monet

art is cool.

Regatta at Sainte-Adresse (detail)
Claude Monet, French, 1840–1926
Oil on canvas, 29 ⅝ × 40 in., 1867
Bequest of William Church Osborn, 1951 51.30.4

Art is vanity,

Lady Lilith (detail)
Dante Gabriel Rossetti, English, 1828–1882
Watercolor and gouache, on paper, 20³/₁₆ × 17⁵/₁₆ in., 1867
Rogers Fund, 1908 08.162.1

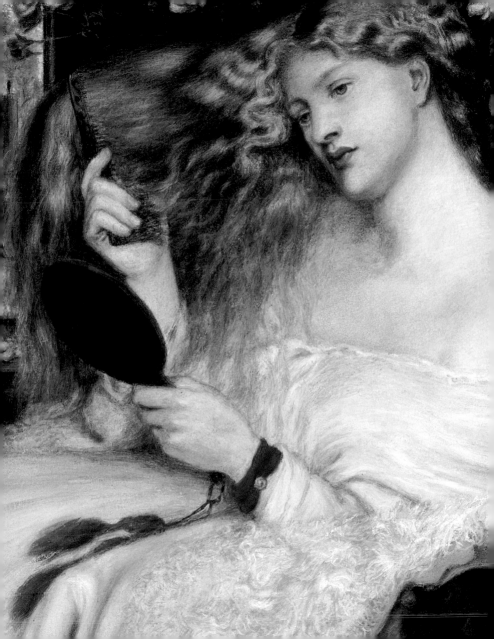

art is self-sacrifice.

Joan of Arc (detail)
Jules Bastien-Lepage, French, 1848–1884
Oil on canvas, 8 ft. 4 in. × 9 ft. 2 in., 1879
Gift of Erwin Davis, 1889 89.21.1

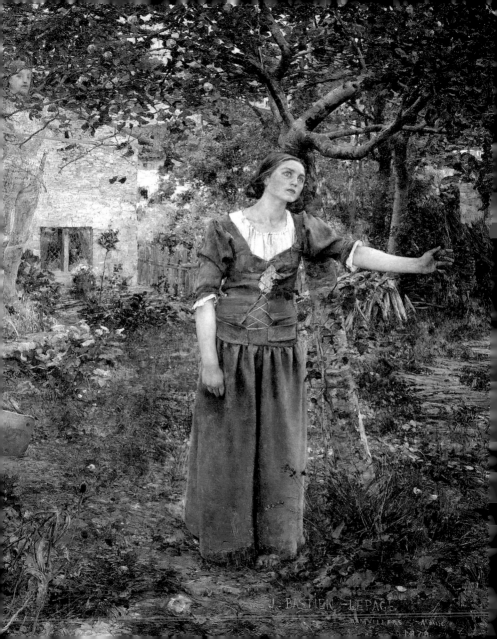

J. BASTIEN-LEPAGE
DAMVILLERS · Meuse
1879

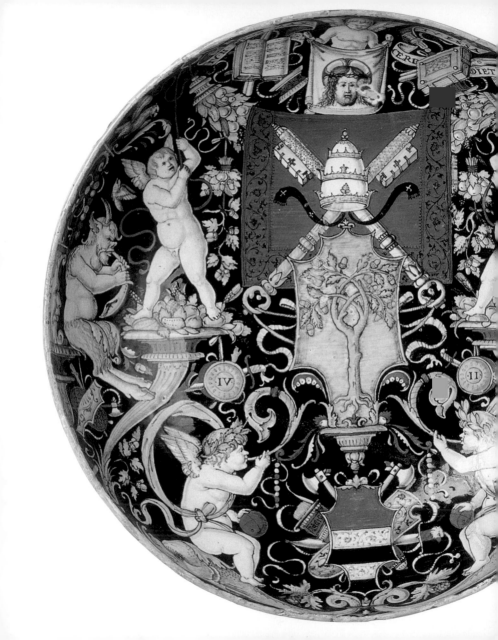

Art is an emblem,

Bowl with the arms of Pope Julius II and the Manzoli of Bologna
surrounded by putti, cornucopiae, satyrs, dolphins, birds
Workshop of Giovanni Maria Vasaro, Italian, active early 16th century
Majolica (tin-glazed earthenware), D. 12^{13}/16 in., 1508
Robert Lehman Collection, 1975 1975.1.1015

art is an icon.

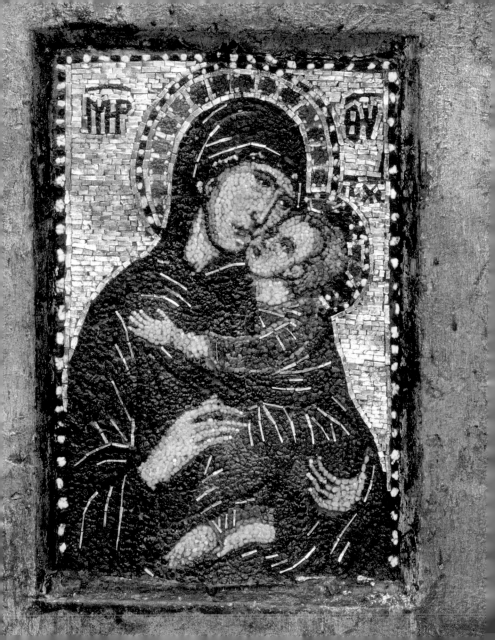

Art is reflection,

Fur Traders Descending the Missouri (detail)
George Caleb Bingham, American, 1811–1879
Oil on canvas, 29 × 36 ¹/₂ in., 1845
Morris K. Jesup Fund, 1933 33.61

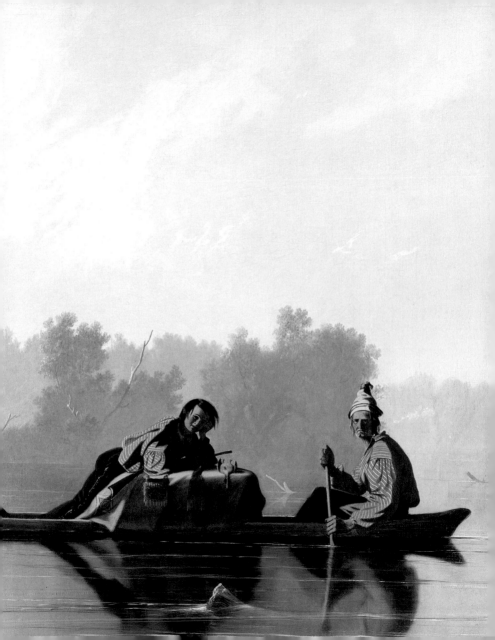

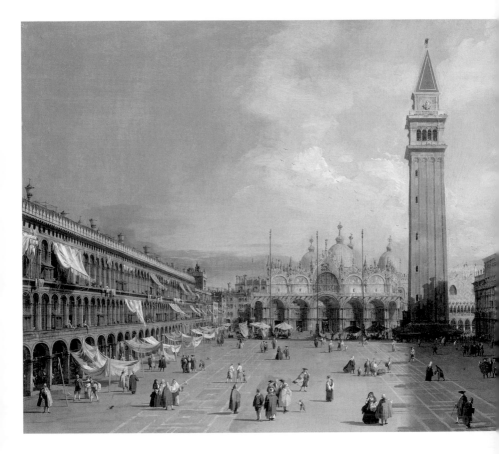

art is perspective.

Piazza San Marco

Canaletto (Giovanni Antonio Canal), Italian (Venice), 1697–1768

Oil on canvas, 27 × 44¹/₄ in.

Purchase, Mrs. Charles Wrightsman Gift, 1988 1988.162

Art is calligraphy,

Night-Shining White (detail)

Han Gan, Chinese, active ca. 742–756

Handscroll; ink on paper, $12^1/8$ x $13^3/8$ in., Tang dynasty (618–907), ca. 750

Purchase, The Dillon Fund Gift, 1977 1977.78

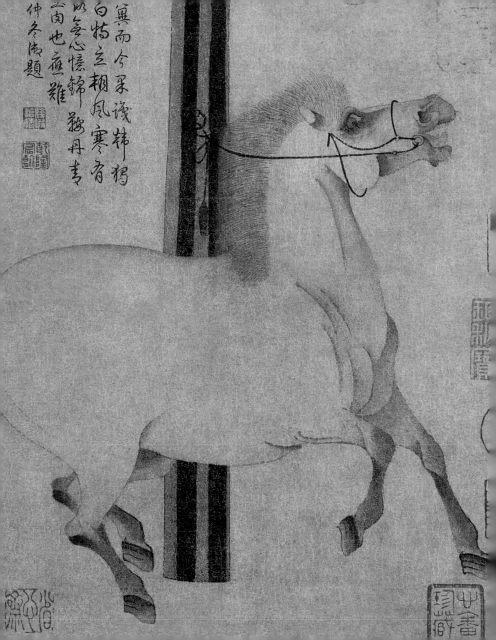

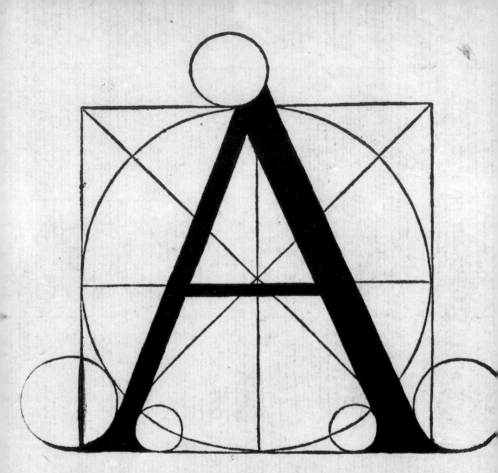

Questa letera A si caua del tondo e del suo quadro: la gāba da man drita uol esser grossa dele noue parti luna de lalteza. La gamba senistra uol esser la mita de la gāba grossa. La gamba de mezo uol esser la terza parte de la gamba grossa. La largheza de dita letera cadauna gamba per mezo de la crosiera. quella di mezo alquanto piu bassa. comme uedi qui per li diametri segnati.

art is type.

Art is polished,

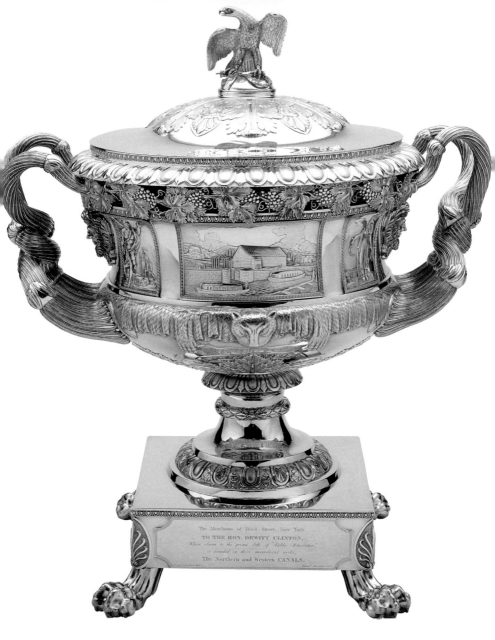

The Merchants of Pearl Street, New York.

TO THE HON. DEWITT CLINTON,
Whose claim to the proud title of "Public Benefactor,"
is founded on these magnificent works,
The Northern and Western CANALS.

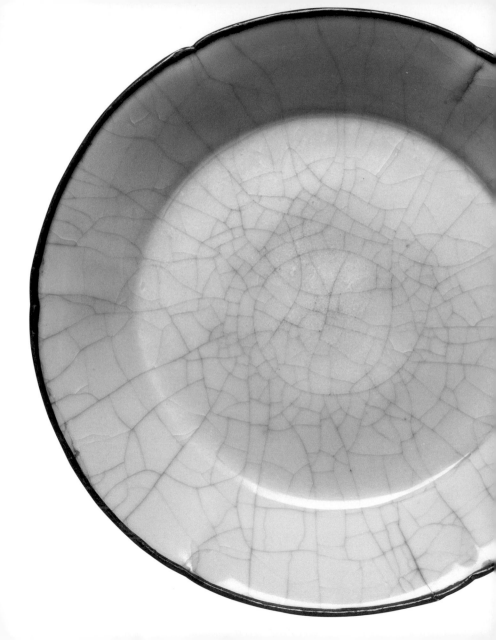

art is crackled.

Art is seen,

Evening dress
American or European, 1884–86
Silk
Gift of Mrs. J. Randall Creel IV, 1963 C.I.63.23.3a, b

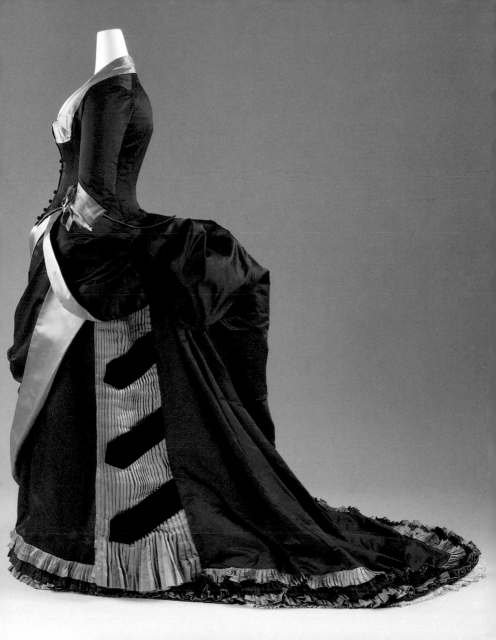

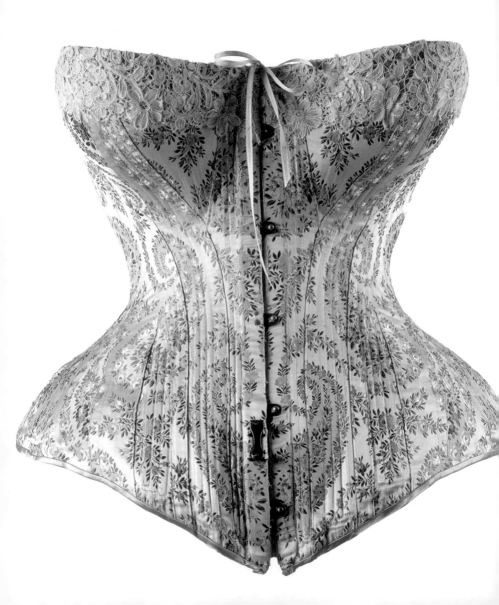

art is hidden.

Art is portrait,

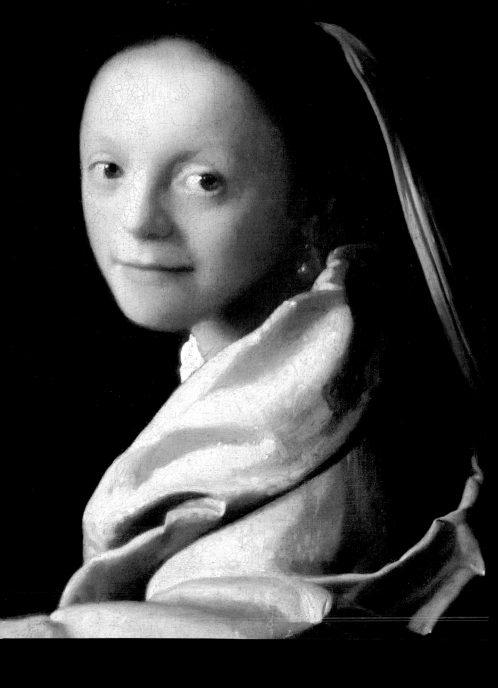

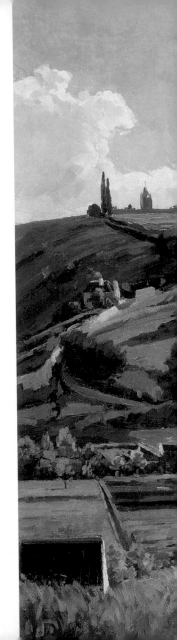

art is landscape.

Jalais Hill, Pontoise (detail)
Camille Pissarro, French, 1830–1903
Oil on canvas, 34 1/4 × 45 1/4 in., 1867
Bequest of William Church Osborn, 1951 51.30.2

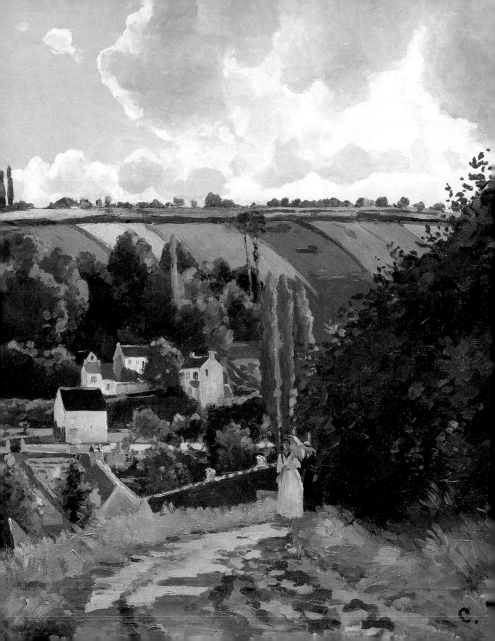

Art is organic,

art is fabricated.

"*Patriot*" Radio
Norman Bel Geddes, American, 1893–1958
Made by Emerson Radio and Phonograph Corp., New York
Catalin, H. 8 in., ca. 1940
John C. Waddell Collection, Gift of John C. Waddell, 2001 2001.722.11

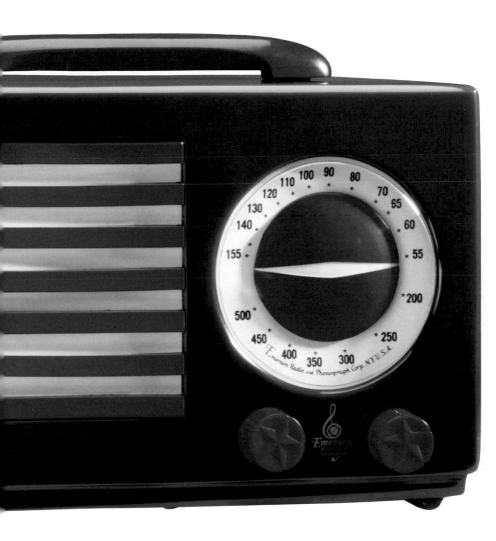

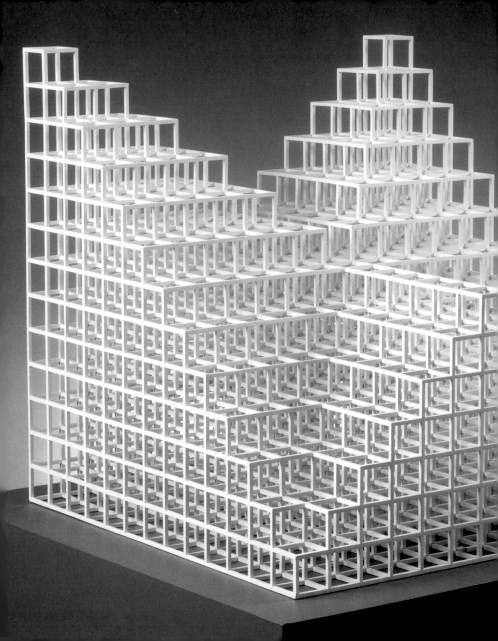

Art is conceptual,

13/3

Sol LeWitt, American, 1928–2007

Painted balsa wood, H. 31 3/8 in., 1981

Purchase, Madeline Mohr Gift and Rogers Fund, 1982 1982.226

© The LeWitt Estate / Artists Rights Society (ARS), New York

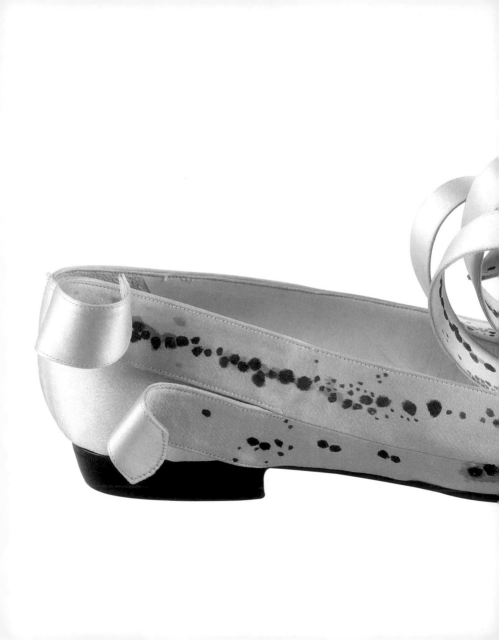

art is representation.

Shoe

Isabel Canovas, French, b. 1945

Silk, leather, spring/summer 1989

Gift of Isabel Canovas, 1989 1989.208.1a, b

Art is geometric,

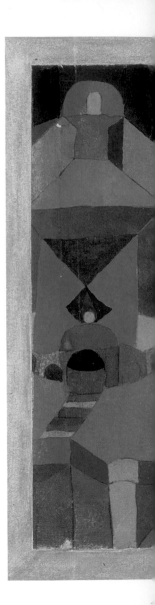

Temple Gardens
Paul Klee, German (b. Switzerland), 1879–1940
Gouache and traces of ink on paper, 7¹/₄ × 10¹/₄ in., 1920
The Berggruen Klee Collection, 1987 1987.455.2

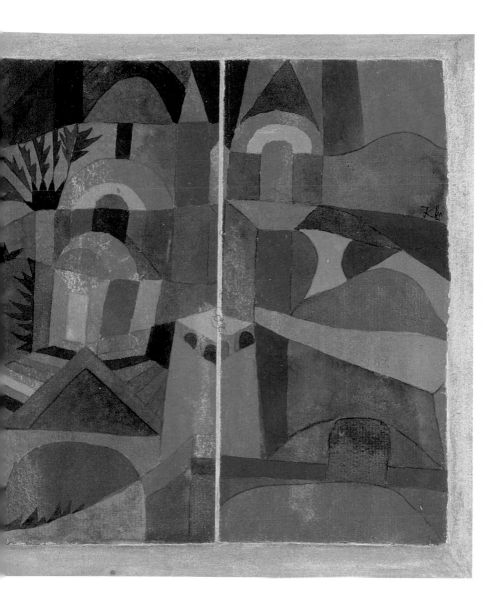

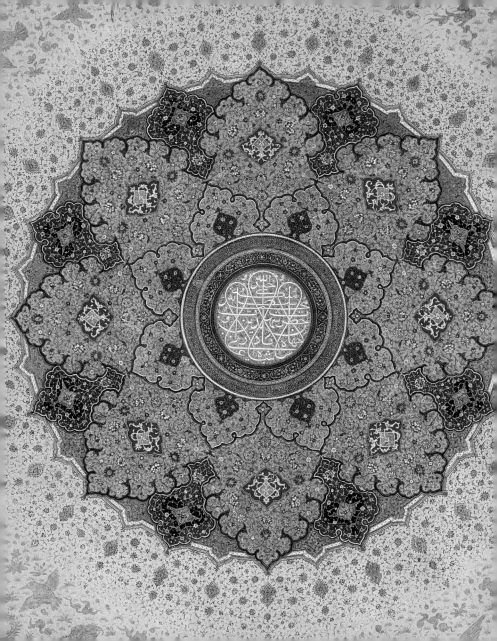

art is arabesque.

Art is rhythm,

Side drum
Ernest Vogt, American, 19th century
Wood, calf skin, rope, D. 16^7/8 in., ca. 1864
The Crosby Brown Collection of Musical Instruments, 1889 89.4.2162

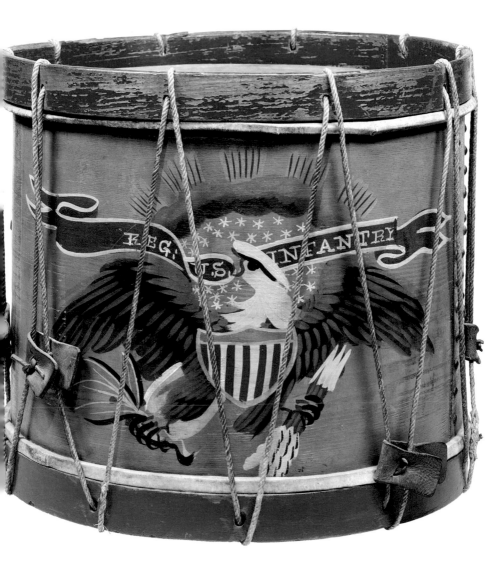

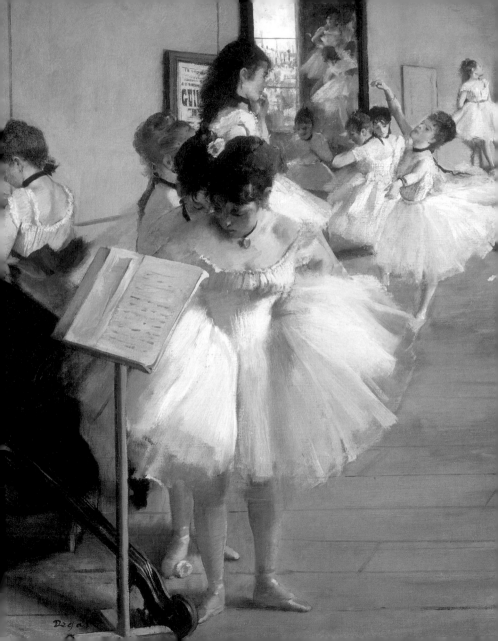

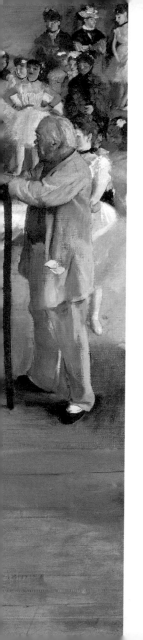

art is dance.

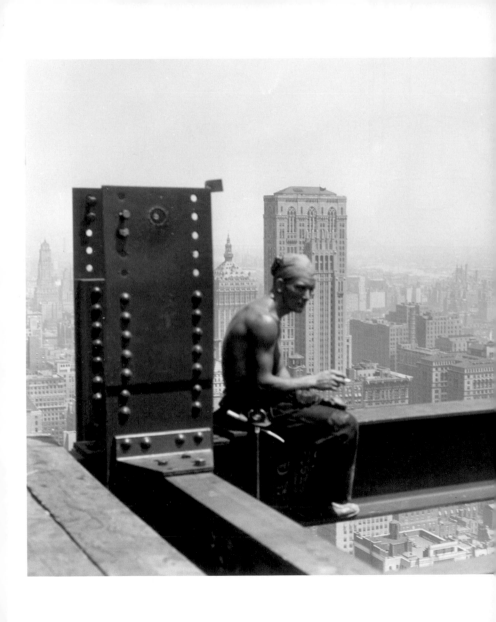

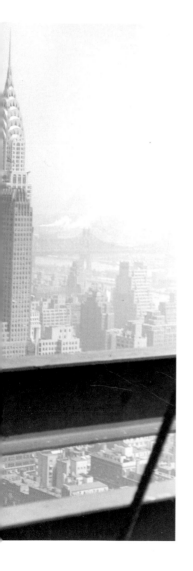

Art is built,

art is abandoned.

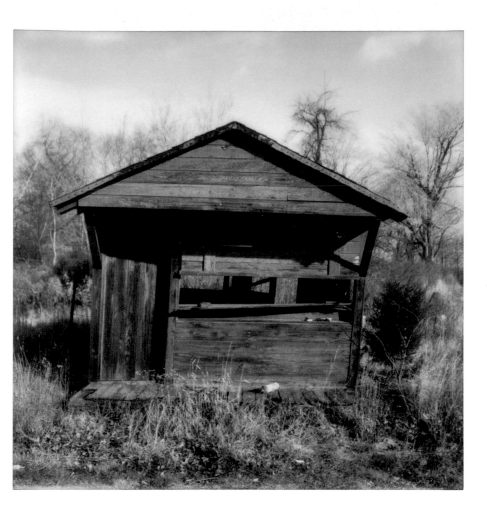

Art is fable,

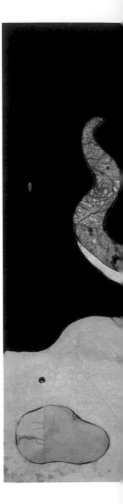

Detail of a cabinet depicting "The Woodman and the Serpent" from *Aesop's Fables*
Made by Galleria dei Lavori, Italian (Florence), 1606–23
Oak and poplar veneered with various exotic hardwoods, with ebony moldings and
plaques of marble, slate (paragon); pietre dure work consisting of colored marbles, rock
crystal, and various hardstones; L. 38^1/8 in.
Wrightsman Fund, 1988 1988.19

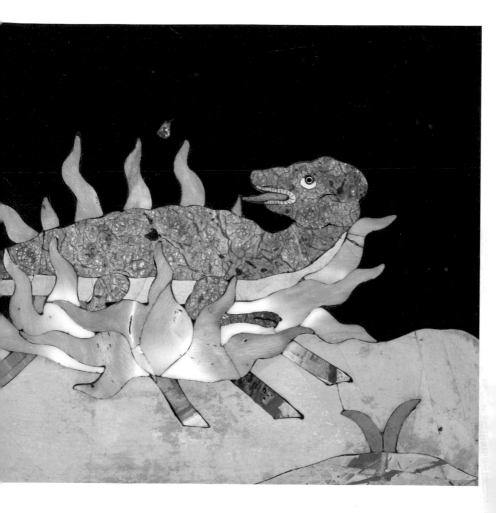

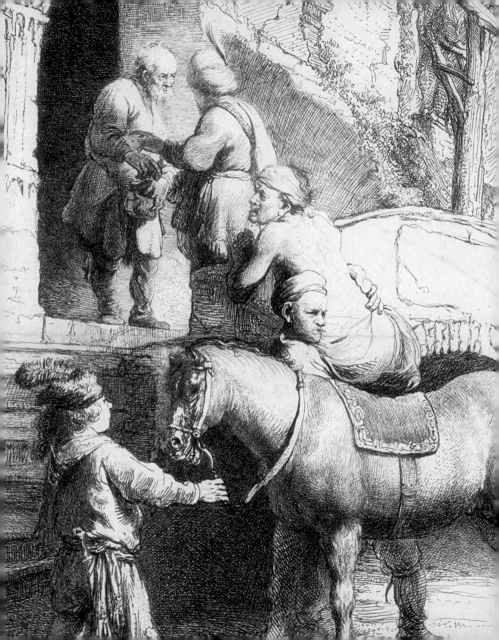

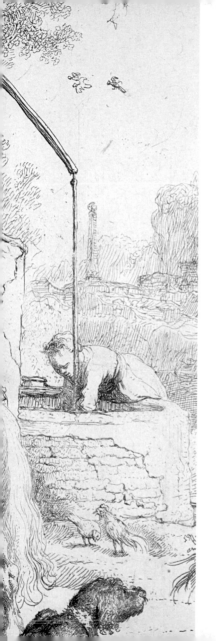

art is parable.

Art is depth,

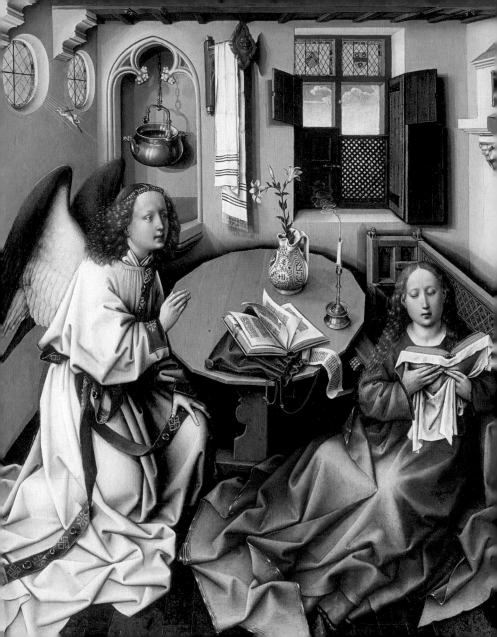

art is illusion.

Art is attentive,

The Little Fourteen-year-old Dancer

Edgar Degas, French, 1834–1917

Bronze, partially tinted, with cotton skirt and satin hair-ribbon; wood base,

H. 38 1/2 in., executed ca. 1880, cast in 1922

H.O. Havemeyer Collection, Bequest of Mrs. H.O. Havemeyer, 1929

29.100.370

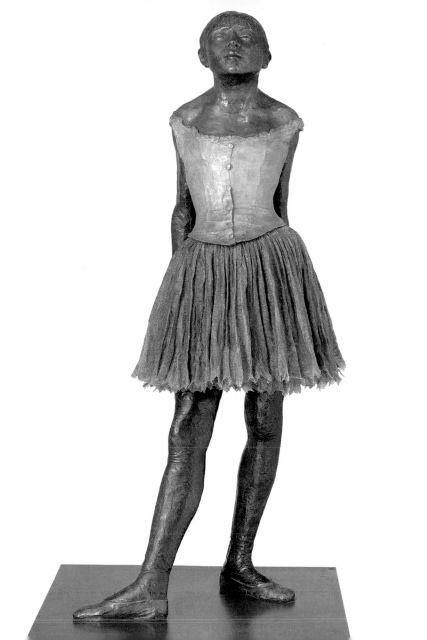

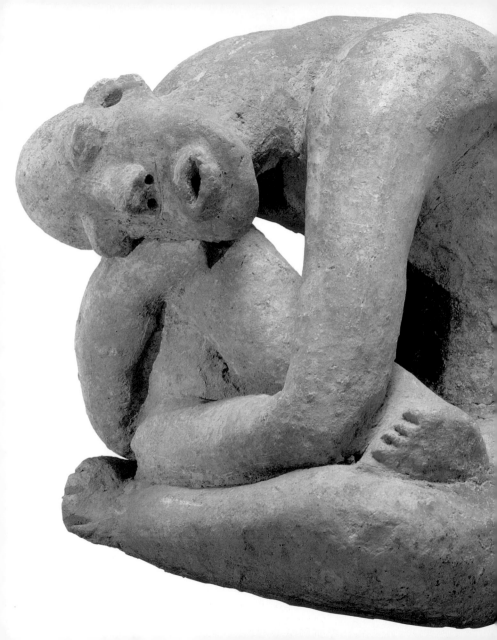

art is weary.

Seated figure
Mali (Djenné), 13th century
Terracotta, H. 10 in.
Purchase, Buckeye Trust and Mr. and Mrs. Milton F. Rosenthal Gifts, Joseph Pulitzer
Bequest and Harris Brisbane Dick and Rogers Funds, 1981 1981.218

Art is suggestive,

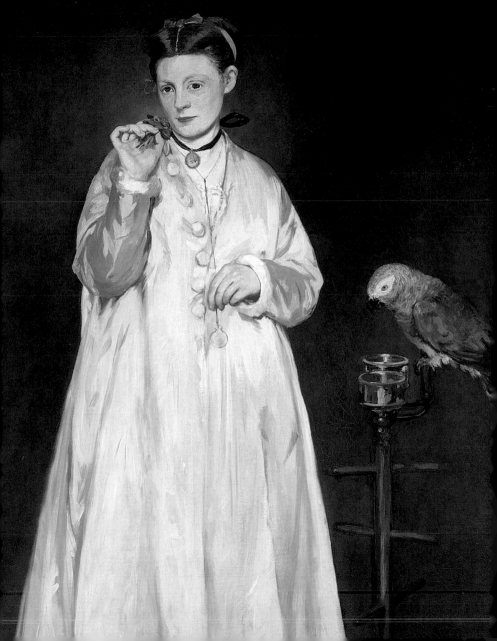

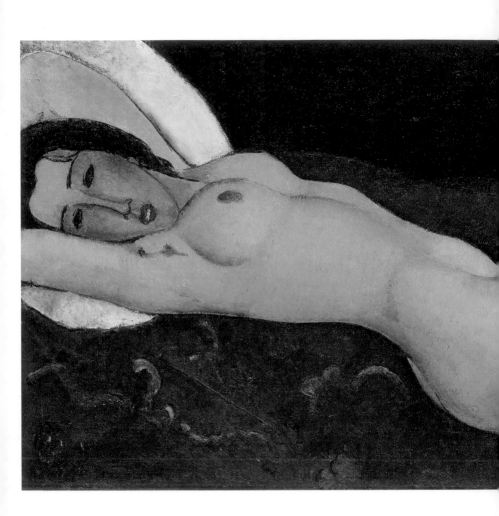

art is revealing.

Reclining Nude
Amedeo Modigliani, Italian, 1884–1920
Oil on canvas, 23 7/8 x 36 1/2 in., 1917
The Mr. and Mrs. Klaus G. Perls Collection, 1997 1997.149.9

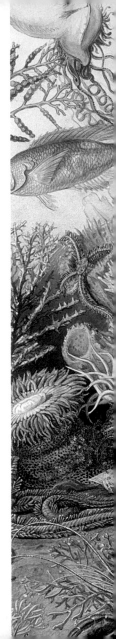

Art is observation,

Ocean Life (detail)
Christian Schussele, American, 1824–1879
James M. Sommerville, American, 1825–1899
Watercolor, gouache, graphite, and gum arabic on off-white wove paper, 19 × 27⁷/₁₆ in.
Gift of Mr. and Mrs. Erving Wolf, in memory of Diane R. Wolf, 1977 1977.181

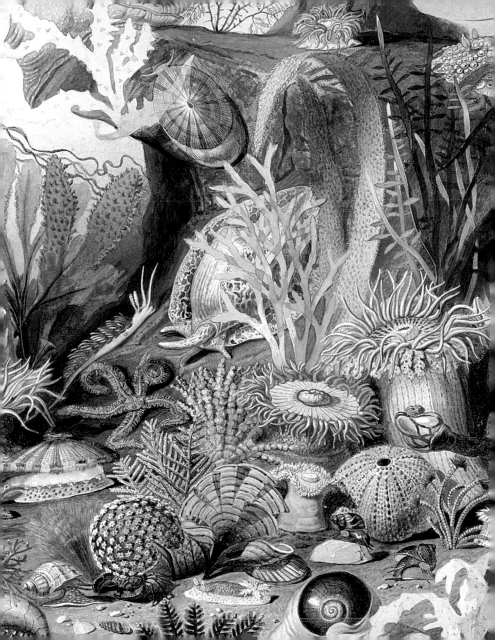

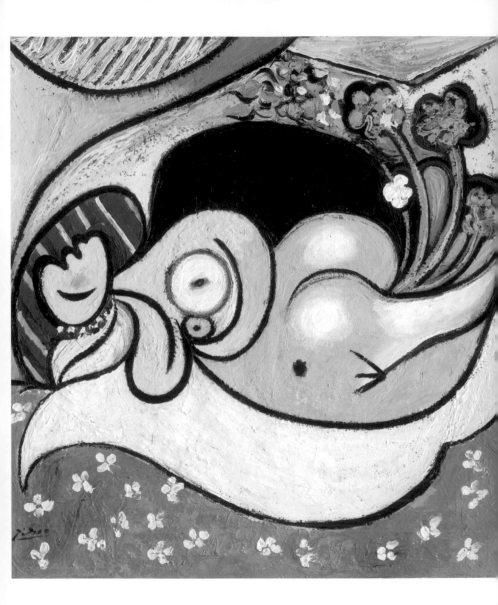

art is imagination.

Produced by the Department of Special Publications, The Metropolitan Museum of Art: Robie Rogge, Publishing Manager; Mimi Tribble, Editor; Mary Wong, Production. Photography by The Metropolitan Museum of Art Photograph Studio.

Cover designed by John Gall. Interior designed by Kate Kennedy.

Library of Congress Control Number: 2013935750

ISBN: 978-1-4197-1125-1

Printed and bound in Hong Kong

10 9 8 7 6 5 4 3 2 1

The Metropolitan Museum of Art
1000 Fifth Avenue
New York, NY 10028
www.metmuseum.org

THE ART OF BOOKS SINCE 1949
115 West 18th Street
New York, NY 10011
www.abramsbooks.com